J. Alden Weir

A Place of His Own

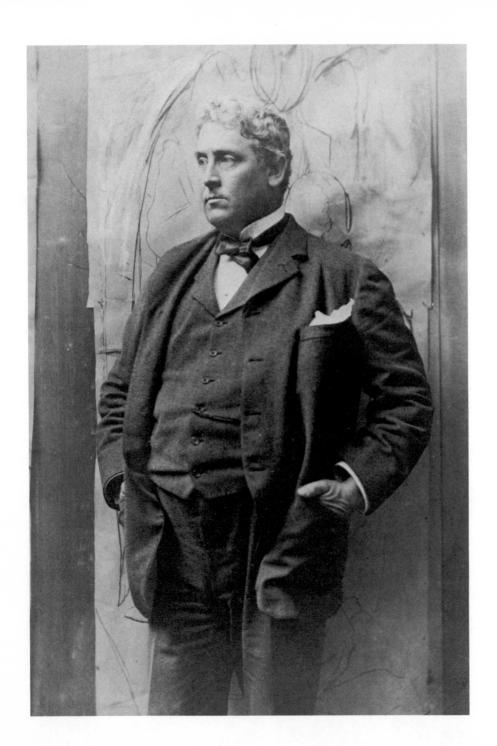

J. Alden Weir
A Place of His Own

Hildegard Cummings
Helen K. Fusscas
Susan G. Larkin

The William Benton Museum of Art
The University of Connecticut, Storrs

Connecticut's State Art Museum

J. ALDEN WEIR
A Place of His Own

The William Benton Museum of Art, Storrs
4 June – 18 August 1991

The Bruce Museum. Greenwich
15 September – 3 November 1991

Cover: J. Alden Weir, *The Laundry Branchville*, c. 1894. Weir Farm Heritage Trust, Gift of Anna Ely Smith and Gregory Smith

Frontispiece: J. Alden Weir. Photograph, Weir Family Papers, Mss P78, Department of Archives and Manuscripts, Harold B. Lee Library, Brigham Young University, Provo, Utah

Library of Congress Catalogue Card Number 91-071C2
ISBN 0-918386-43-8

Library of Congress Cataloging-in-Publication Data
Cummings, Hildegard,
 J. Alden Weir: a place of his own/Hildegard Cummings, Helen K. Fusscas,
 Susan G. Larkin
 p. cm.
 "The William Benton Museum of Art, Storrs, 4 June-18 August 1991.
 The Bruce Museum, Greenwich, 15 September-3 November 1991"-
 T.p. verso.
 Includes bibliographical references.
 ISBN 0-918386-43-8
 1. Weir, Julian Alden, 1852-1919—Exhibitions. I. Fusscas, Helen K., 1943-
II. Larkin, Susan G., 1943- . III. William Benton Museum of Art. IV. Bruce Museum. V. Title.
ND237,W4A4 1991
759. 13—dc20

 91-3668
 CIP

Contents

Preface
Constance Evans 7

Preface
Gerald D. Patten 9

Foreword
Paul F. Rovetti 11

Acknowledgments
Hildegard Cummings 13

Home is the Starting Place
J. Alden Weir and the Spirit of Place
Hildegard Cummings 15

The Mystery of a New Path
The Art of J. Alden Weir
Helen K. Fusscas 37

A Curious Aggregation
J. Alden Weir and His Circle
Susan G. Larkin 59

Color Plates 79

Chronology 97

Selected Bibliography 99

Preface

Experiencing Weir Farm, Connecticut's newly designated National Historic Site, is indeed like stepping into a marvelous time warp—that special place where past and present merge. One can almost feel the presence of J. Alden Weir (who acquired the farm in 1882), his family, and his circle of friends. The magnificent landscape, outlined by familiar stone walls, remains virtually unchanged, in both its physical character and in its ability to inspire the creation of art.

In organizing such a timely exhibition, *J. Alden Weir: A Place of His Own*, the William Benton Museum of Art provides a wonderful opportunity to examine the full range of work produced by this important American artist and the context in which it was created.

As Lawrence W. Chisolm wrote in his introduction to *The Life and Letters of J. Alden Weir*, by Dorothy Weir Young,

> *Weir's paintings at their best restore us too, not in the spirit of nostalgia or of escape to a pastoral refuge, but as celebrations of a modest ideal of life. In trying to render 'the mystery that it all is' Weir conveys a sense of place, an acceptance of a rooted life seldom flamboyant or dramatic, a life aptly embodied in the particular Connecticut countryside he loved.*

The Weir Farm Heritage Trust applauds the extraordinary efforts of the Benton's curators, who have gone to great lengths to organize this exhibition in a time frame that would herald Weir Farm's recent inclusion in the National Park system. The exhibition pays just tribute to J. Alden Weir, who not only made significant contributions to American art as a painter, but was also committed to heightening the conditions in which great art could flourish.

We thank The William Benton Museum of Art for encouraging the examination and appreciation of J. Alden Weir, his work and his life in Connecticut, and for providing the recognition that Weir so well deserves.

Constance Evans
Executive Director, Weir Farm Hertiage Trust

On behalf of the National Park Service, U.S. Department of the Interior, I wish to congratulate The William Benton Museum of Art on the opening of this very important exhibition, *J. Alden Weir: A Place of His Own*.

As you know, Weir's home, studio, and the surrounding landscape he loved were recently added to the National Park System as Weir Farm National Historic Site. Not only does this represent Connecticut's first National Park unit, it is our only site dedicated to preserving and interpreting a place associated with an American painter. When fully activated in the coming years, it will join Saint-Gaudens National Historic Site in Cornish, New Hampshire, in helping us to tell the story of our great American artists and their role in the nation's cultural development.

Many of the superb paintings you have included in the exhibition were inspired by scenes familiar to Weir, and which may still be enjoyed at Weir Farm by contemporary visitors. Your ability to organize this show and to be able to exhibit it as well at The Bruce Museum in Greenwich in the fall is also encouraging, reinforcing the ongoing partnership of individuals and organizations committed to making the site a true national model. We look forward to working with you as we develop plans and programs so that future generations may enjoy "the quiet, plain little house among the rocks" that Weir called home.

Gerald D. Patten
Regional Director, National Park Service

Amazingly, no collection of the works of J. Alden Weir has until now been on public view in the state where he created nearly all of them a century ago. This exhibition corrects that oversight and celebrates besides the naming of Weir Farm in Branchville as Connecticut's first National Historic Site.

J. Alden Weir (1852-1919) grew up in the Hudson River Valley and spent most winters after that in New York City, but he is, without a doubt, a Connecticut artist. For thirty-seven years, between 1882 and 1919, he lived and worked for months at a time on his own farm in Branchville and at his wife's family place in Windham Center. His landscape art is a celebration of the Connecticut countryside that he loved. Though he painted scenes that were on his own grounds or near them, he found beauty everywhere in our state. And he saw most of it, traveling back and forth between Branchville in the west and Windham in the east.

At least once Weir drove cattle from Branchville to Windham, and admired on the way the "beautiful prospect" of Newtown. He fished in Lake Pocotopaug at East Hampton, where he had better luck than in his own pond in Branchville. He went up Spring Hill by carriage or wagon to Storrs Agricultural College, forerunner of The University of Connecticut, so that Paul Remy, his manager at Branchville, could learn the newest farming methods. He and a daughter traveled by horse and carriage from Windham Center to Middletown, a "good trip" that only took from nine in the morning until six-thirty in the evening. "Prancer" needed shoeing the next day and a rainstorm delayed them further, but Weir and Cora stayed the next night at a favorite colonial inn in Meriden.

At the train station at South Norwalk, Weir passed the time between connecting trains by scratching images onto etching plates small enough to fit into his pocket. He had introduced John Henry Twachtman to the process and worked with him on scenes of the footbridge in Bridgeport harbor. Often they were together at Cos Cob, Greenwich, or Branchville, painting, teaching, or talking art. The train rides that the entire Weir family took between Branchville and Windham, with a change at Hartford, were noisy, cheerful affairs, especially when a daughter's pet canary got loose in the coach. There were frequent family reunions, too, in New Haven, where brother John Ferguson Weir was director of Yale University's Art School.

Artist friends such as Childe Hassam, Emil Carlsen, and Albert Ryder came to Branchville and Windham for weekends or for visits that lasted for days. It is pleasant

to think that one day during his last summer, Weir took John Singer Sargent to the Nathan Hale Homestead in Coventry, where midway through the visit Sargent happily startled the group by bursting out of a secret stairway.

Weir's place in American art is secure. Now that his place in Branchville will be preserved as well, people can take their friends there, just as Weir took his friends to see how Nathan Hale's family had lived. Artists will sketch, paint, and photograph at Weir Farm, and scholars will study the work of Weir and the artists who visited him there, as well as the art of sculptor Mahonri Young, who lived there afterward, and painter Sperry Andrews, who lives there still. Weir would have liked that.

Paul F. Rovetti
Director, William Benton Museum of Art

Acknowledgments

The surprisingly rapid success at the federal level of efforts that led to Weir Farm being named Connecticut's first National Historic Site, and the first dedicated to an American painter, was cause for celebration last fall throughout Connecticut. To mark this significant happening, The William Benton Museum of Art, *Connecticut's State Art Museum*, which had been planning a J. Alden Weir exhibition for later, rearranged its schedule to offer a look at some of Weir's best paintings now. While exhibitions and publications do not come into being without the hard work and support of many people and institutions, those that happen sooner than first scheduled involve especially deep gratitude of several kinds.

We thank the Connecticut Commission on the Arts for the financial support that made this exhibition possible. (The funds of this state agency are recommended by the Governor and appropriated by the State Legislature.) We thank the family of J. Alden Weir, without whose wholehearted support there could be no exhibition. Near and distant relatives alike were always ready to answer questions and allow intrusions into their lives. We especially thank Charles and Adair Burlingham, William and Elizabeth Anne Carlin, Caroline P. Ely, and Gregory and Anna Ely Smith. We remember and appreciate conversations with the late Cora Weir Burlingham and could have done little without the publications of Caroline Weir Ely and, especially, Dorothy Weir Young's *The Life and Letters of J. Alden Weir* (1960).

Lenders to the exhibition have shared information as well as art. We thank them. Special thanks are due Virgie D. Day, who oversees the art collection at Brigham Young University in Provo, Utah, and her splendid staff, especially Julia Lippert and Dawn Pheysey. We also thank art conservator Richard J. Trela, and Dennis Rowley and his staff at the Department of Archives and Manuscripts at Brigham Young's 'Harold B. Lee Library, who brought dimensions to this project that were invaluable. We look forward to the time when Brigham Young's important collection of the works of J. Alden Weir are installed in the new museum that is under construction at Provo.

For essayists Helen K. Fusscas and Susan G. Larkin, this was a labor of love, accomplished despite other professional commitments. We are deeply grateful. All three authors owe a heavy debt to the research of Doreen Bolger, whose comprehensive study, *J. Alden Weir: An American Impressionist* (1983), will always be the basic 20th-century work on this artist. We thank Ms. Bolger, too, for lending transparen-

cies for reproduction in this publication. Without financial support, there would be no publication, and it is a pleasure to acknowledge and publicly thank these donors: The Bruce Museum; The Chronicle Publishing Company; The Daphne Seybolt Culpeper Memorial Foundation, Inc.; The Vernon K. Krieble Foundation; The Connecticut Commission on the Arts; Weir Farm Heritage Trust; Friends of The William Benton Museum of Art; and the Museum Shop of The William Benton Museum of Art. We also thank the Connecticut Humanities Council, state committee of the National Endowment for the Humanities, for support of an exhibition brochure.

We owe personal thanks to Constance Evans, Director of Weir Farm Heritage Trust, and Terry Tondro, President, Board of Directors, Weir Farm Heritage Trust; to Sarah Peskin at the National Park Service; to Carôn Caswell Lazar for design and production of this publication; and to staff members at the Benton Museum and the Bruce Museum, as well as at numerous other museums, research libraries and archives.

Hildegard Cummings
Curator of Education, William Benton Museum of Art

Home is the Starting Place
J. Alden Weir and the Spirit of Place

Hildegard Cummings

J. Alden Weir (1852-1919), painter of figures, still lifes, and Connecticut landscapes, was one of the most respected artists of his time, so it is not surprising that tributes to him have been numerous. An odd bit of praise came from James Flexner, who wrote glowingly not of Weir, whom he had never met, but of the artist's summer home. Flexner was utterly enchanted by "a Connecticut farmhouse on whose walls paintings bloomed as naturally as flowers in the surrounding fields." This home, Flexner declared, had to be one of the most delightful in America, and so, by implication, were the artist and family who had lived there.

> In the studios on the back meadow, in the parlor with its antlers and two huge fireplaces, in the ramble of chambers where so many artists had stayed, even in the dark crannies of the stairwell, there were clusters of pictures, the results of personal friendship, of esthetic love. Many showed views visible through the windows. Others renewed in ghostly echoes voices that had once filled these rooms.[1]

More than one visitor had been struck by the sight of a pitchfork outside the simple farmhouse and a Whistler etching inside, "seemingly unaware of their differences and in blissful incongruity," as Joseph Pearson, an artist who knew the place well, liked to remember.[2] Julian Alden Weir was aware that his house and farm were special. He had created the home in Branchville, in the western Connecticut countryside, and he lived there what John Singer Sargent said was "the finest life I have ever seen."[3] While farming it was often a struggle, the place gave Weir deep pleasure and contentment and the sights, insights, and inspiration for his art. For us, the farm at the crest of Nod Hill can lead to a better understanding of both the artist and the art. Weir not only found most of his subject matter on home ground, but he also had a strong sense of Home.

In 1892 he received a poem from the young son of his friend John Henry Twachtman, which took as its subject the brook on Twachtman's Greenwich property that Twachtman was immortalizing in his art. Weir told his namesake Alden that

> There is another, a greater stream which this little one will teach you much about—the stream of life—home is the starting place and love the

[1] James Thomas Flexner, "In the Genteel Tradition of Another Day," New York Times Book Review, Jan. 1, 1961.

[2] Joseph Pearson's letter to Dorothy Weir Young; quoted in Young, The Life and Letters of J. Alden Weir (New Haven: Yale University Press, 1960), p. 194.

[3] Quoted in Mahonri Sharp (Bill) Young interview, Aug. 7, 1989, p. 11, Oral History Collection, Weir Farm Heritage Trust.

guide to your actions. Great men who loved their homes and were kind and generous to their playmates in their youth, learned many truths which were of much value to them all through their lives.[4]

Weir's own childhood home in West Point, New York, was a place that had undoubtedly set the direction of his life. His father, Robert W. Weir (1803-1889), was a noted painter and the professor of drawing at the military academy. J. Alden Weir spoke often of the joys of the home and large family (sixteen children) at West Point, but seldom more movingly than in an 1876 letter to his parents from Paris, where he was studying art. Robert Weir was retiring, and the family had to leave the house on the Point. Though the news was expected, the young Weir was saddened, and in his imagination he "took a walk all over, visiting the places where I had so often trod in the days dearest to me." His memory trail led first to his father's studio, or the painting room, as the family always called it. Here were paintings from floor to ceiling, portfolios of prints and drawings by famous artists, a suit of armor, plaster casts and "familiar old relics" to be found amid a jumble of mannequins, antique furniture, rolls of canvas, and pots of paint. Weir loved the large north window that brought the Hudson River Valley almost into the studio itself. He imagined then that he heard his father calling him to take a walk. They had set off, having a good talk about art as they went:

> When we returned old Fido barked at us in front of Mr. Mahan's house, and when we got by the black gate we saw the girls and Charley returning from the parade. We all dined together and afterwards saw the sun set from the front porch. It seemed to me today as if I had really been with you all for I retraced those good old days with so much pleasure.[5]

Such memories are revealing. For Weir, ever afterward, home would mean family and friends, pets, a painting room, an ample dining room, a comfortable veranda, interesting furniture, beautiful pictures and "relics"—and extensive home grounds for rambling about in. One should only add religion to this mix, because Robert Weir instilled in his family a strong sense of the spiritual that was closely tied to a love of nature. Weir was passing on what he himself had learned when he told Alden that the charm of the boy's poem was surpassed only by "looking at these beautiful things which God has given us to enjoy with your own eyes, and beginning early to love this little stream that runs by your home."[6]

Weir began planning his own future home when he met Anna Dwight Baker, whom he married in 1883. He wanted it to be much like the ones they had grown up

[4] *Letter from J. Alden Weir to Alden Twachtman, Jan. 3, 1892; in Young, p. 177.*

[5] *JAW to his parents, Sept. 5, 1876; quoted in Young, pp. 104-5.*

[6] *JAW to Alden Twachtman, Jan. 3, 1892; in Young, p. 177.*

in, where the tasks of daily living did not interfere with the leisure to learn and grow. Writing her after visits to her family's place in the village of Windham, Connecticut, some thirty miles east of Hartford, he liked to think of her reading Emerson or Shakespeare in the big red chair in front of the fireplace, or in the windowseat in her bedroom, with a pet in her lap or at her feet. He sent etchings to decorate her room and others in the house, and cushions to look well with a tapestry she had. Her engagement gift from him was his oil portrait of her favorite dog, Bush.[7]

Their ideal home would have nature at the doorstep, for they both took deep pleasure in the natural world around them. The nature they loved best was neither raw wilderness nor an artificially contoured and planted landscape, but plain old New England farmland and the concomitant hills, streams, and woods. Nature such as this, especially when suffused with the spirit of home, family, and friends, offered enjoyment and opportunity for contemplation in all seasons and in any leisure hour. Weir had grown up in such a paradise at West Point, where he had hunted, fished, and tramped the hills and valleys until he knew every inch. Now, visiting Anna at Windham, he loved not only her but her home ground, and that mostly because of her. "When I return from your lovely place I am homesick," he told her. "The ground you walk on I love."[8] Anna's green fields in Windham, marked by trees, a pond, and an occasional stile where her golden hair looked to advantage against the sky as he helped her climb over, prompted Weir to dream of endless wanderings, "where no sounds but those of the birds or insects will chime in with our pleasant reading."[9] These are the words of a man in love, but Weir's views of the natural world were never to change very much. Nature would be for him an endless source of pleasure and inspiration.

Anna must have known it would please him to write what she saw and felt on her walks about her family's farm and it did. "Your description of the scenery was beautiful," he wrote from his studio in New York.[10] She seemed as sensitive as an artist to nuances of color and light. Weir's own accounts of the outdoors at Windham reveal a preference for either full sunlight or for "walking in the moonlight, when we can wander and watch the beautiful forms that the shadows will make."[11] Both kinds of light were to become essential to his landscape art.

Besides loving nature more when he could associate it with the people he loved, Weir took pleasure in the visible connections with the past that nature offers. He liked knowing that Henry Hudson and he had looked at the same scenery at West Point. He was shocked when Anna's uncle decided to cut down some old trees on the Windham property: "I cannot imagine anyone who was in any way connected with the

[7] JAW to Anna Dwight Baker, {date?}, 1882; J. Alden Weir Papers, Archives of American Art, roll 125. Frame numbers are often illegible on this roll.

[8] JAW to ADB, May 24, 1882, and Apr. 28, 1882; JAW Papers, AAA, roll 125.

[9] JAW to ADB, {1882}; JAW Papers, AAA, roll 125.

[10] JAW to ADB, Apr. 30, 1882; JAW Papers, AAA, roll 125.

[11] JAW to ADB, May 19, 1882; JAW Papers, AAA, roll 125.

place ever destroying such fine old relics of the past."[12] At Branchville he bought a stand of trees rather than see them destroyed, and he was so grieved when the last great elm in Windham needed to be cut down that he sent a final photograph of it to a friend in Oregon. Weir often depicted venerable trees in his landscape art in combination with slender saplings or blossoming bushes. He might simply have been making art of what he saw, but Weir's delight in the wonderful power of nature to renew itself can be documented in his letters.

As he planned his marriage, Weir had an idea for a summer place in the Adirondacks. He would live in New York City the rest of the year, in order to gain the portrait commissions he was counting on as primary income and take full advantage of opportunities to exhibit his work. Anna, whose family had for some years wintered in New York, when not on one of their extensive tours abroad, was looking forward to an urban life, for she confessed that she occasionally found country life dull. She agreed, however, that it was important to live in the country at least two months of the year. Weir had decided on Keene Valley in the Lake Placid region of the Adirondacks on the advice of artist Roswell Morse Shurtleff, a New York landscapist who had been painting in the Adirondacks every summer for at least ten years. Shurtleff had just bought an entire hill there and suggested that Weir might like the one next to it. One look convinced Weir, and he purchased the knoll in August 1882, with the hope that Twachtman would buy part of it from him and become his nearest neighbor. That seems never to have happened, but Twachtman did visit. On August 26, Weir wrote Anna that he had had an exciting day. Shurtleff, Twachtman, and Stanford White, who was designing the house, had helped Weir select the site for it. Weir included rough sketches. A great room measuring twenty by forty feet would have walls of stone and a chimney up to nine feet wide by six feet high. The rest of the house was to be built of logs. A porch would line the front. The house was a fine example of the emerging "Adirondacks style," more Bavarian hunting lodge than American log cabin.[13]

Weir and Shurtleff were not alone in thinking that a summer retreat in the Adirondacks was desirable. A back-to-nature movement had been developing in America since the Civil War, fostered certainly, but not entirely accounted for, by the crowds, noise, and foul air of big cities and by improvements in transportation that enabled more people to travel. By the 1880s it was in full swing. It had little to do with the old Jeffersonian myth, which held that farmers, close to nature and shielded from the corruption of cities and commerce, were America's best people. The urban intellectuals who first embraced the new movement, as well as the middle classes who

[12] *JAW to ADB, May 19, 1882; JAW Papers, AAA, roll 125.*

[13] *JAW to ADB, Aug. 26, 1882; JAW Papers, AAA, roll 125.*

18

took to it later, were generally indifferent to or even wary of farmers and farming but were moved by the spiritual resources that rural scenery offered. Many historians have attributed the rise of the 19th-century's unabashed "nature lover" to city dwellers' nostalgia for a country childhood, and that may well have played a large part. J. Alden Weir, though not a farm boy, shared fond memories of a childhood rooted in country pleasures with many other Americans of his era. But some who have studied late 19th-century attitudes toward nature in America, such as Peter J. Schmitt, have argued that city people grew to regard rural scenery, country living, and even sports in a special way, as only city people could.[14] While still an art student in France, Weir unconsciously supported this view and even offered the reasonable explanation that a period of city living makes nature seem "more rich than ever and full of charm, which one can only appreciate by being away from it." After passing a winter in a city, even the smallest moss-covered rock seems in itself a picture, he told his parents.[15]

City residents in late 19th-century America wanted the best of both city and country. A rash of new country life and home decorating periodicals in the 1880s and '90s advised urban readers how to get "the cream of the country and the cream of the city, leaving the skim milk for those who like that sort of thing."[16] These words, though not written until 1922 for a book called *City Homes on Country Lanes*, were as apt for nature lovers of the Gilded Age as for their grandchildren in the 1920s. As early as the 1850s, Donald G. Mitchell, an editor for *Harper's* magazine, had begun to write of the "retired life" in a half dozen books of essays under the pen name Ik Marvel. His hero was a sophisticate who had no taste for sharing his country dinner with farmers with "horny hands, tired body, haydust." "A long day of fieldwork leaves one in a very unfit mood for appreciative study of either poetry or the natural sciences," Mitchell sniffed.[17] His successful advertisement for a farm of his own specified that it must be within three hours of Manhattan, have no less than a hundred acres, twenty of which must be woods, and include a southern or eastern slope, a running stream, and a water view. He may have hired someone to do the farm work, but many city people who bought abandoned farms cultivated no crops. They added porches and plumbing while fences drooped and fields sprouted goldenrod and Queen Anne's lace. The scraggly look of unattended land pleased them.

That the park and conservation movements were concurrent with city dwellers' moves to the suburbs and summer migrations to the country is no coincidence. The belief was strengthening into a firm conviction that people who lived in cities must have at least occasional contact with nature. This was a period that saw the establishment of city parks and playgrounds, summer camps for children, nature study in the

[14] Peter J. Schmitt, *Back to Nature: The Arcadian Myth in Urban America* (New York: Oxford University Press, 1969).

[15] JAW to his parents, Apr. 6, 1877; quoted in Young, p. 122. "The city life," Weir added, "where one is imprisoned amongst walls, makes one's faculties more appreciative."

[16] William Smythe, *City Homes on Country Lanes* (New York: Macmillan, 1922), p. 60.

[17] Donald G. Mitchell, *My Farm of Edgewood* (New York: Scribner's, 1894; 1st ed. 1863), p. 256.

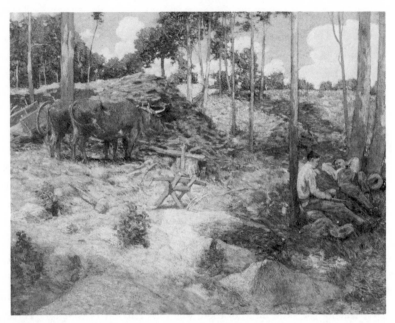

Fig. 1
J. Alden Weir, Midday Rest in New England, *1897, oil on canvas, 39½ x 50 in., signed at lower right: J. Alden Weir—1897/—Branchville, Conn. (Pennsylvania Academy of the Fine Arts, Gift of Isaac H. Clothier, Edward H. Coates, Dr. Francis W. Lewis, Robert Ogden, and Joseph G. Rosengarten).*

classroom, the transformation of hunting and fishing into gentlemen's sports, and the creation of such new games as tennis and croquet. Weir, himself an avid hunter and angler, worked alongside his hired hands to make a tennis court at the Branchville farm. The great red oxen seen in *Midday Rest in New England*, 1897 (fig. 1), hauled aside the boulders on the site.[18] In the city, he made good use of Central Park, often hitching his horse at the door of the Metropolitan Museum of Art while he went in to see old favorites and new acquisitions, several of which he had helped the museum to acquire.

Interest in the Adirondacks region had begun in the late 1850s and intensified in the 1870s. These mountains, and others in the eastern United States, attracted hardy souls who liked their scenery wild, yet closer to home than the great ranges of the American West. When J. Alden Weir went to Keene Valley in 1882, there was a hotel with citified amenities, but guides for hunting and fishing expeditions were still a necessity for even such experienced campers and fishermen as he. Weir was fascinated to hear that camping excursions exclusively for women were available here, and he hoped that Anna might try one sometime. He worried that she might sometimes be lonely and was glad that Mrs. Shurtleff would be a neighbor.[19] There are hints, however, that his worry should rather have been that Keene Valley would soon be overrun with people.[20] Hopes that his house would be finished by the fall of 1882 were

[18] *Joseph Pearson's letter to Dorothy Weir Young; quoted in Young, p. 194.*

[19] *JAW to ADB, various letters, July-Aug., 1882; JAW Papers, AAA, roll 125.*

[20] *Years later, in 1903, Wilfred de Glehn, a British artist who had camped out on Weir's Branchville farm for a few days, sent a thank-you note from the Adirondacks (quoted in Young, p. 206): "I write you—as from a different country, so great is the change here after the quiet, peaceful and pastoral Branchville."*

dashed when he discovered that so much building was going on that he could not get enough seasoned timber.[21] He bought an ax with which to do some judicious clearing but little more got done that summer than the house foundation, some piping for water, and a start to the icehouse. He attempted to sketch and paint the landscape but was frustrated with those efforts, too.

Back in New York at the end of October, Weir looked forward to a spring wedding and an extended honeymoon abroad. "But the pleasures of wandering," he warned Anna, "must not wean us from the feeling of home, and it is for this reason that I endeavor to make for you the humble lodge in the mountains, that we will have something to make us feel that we have a little home to look after."[22] Earlier, Twachtman had congratulated Weir on his engagement with a similar thought: "You will have your own home."[23] Whether the lodge in the Adirondacks was built is doubtful. By 1889 Weir was fretting that he had been unable to sell the property, and, in any case, there is no evidence that the Weirs ever lived there. Instead, they discovered the house at Branchville that has now become Connecticut's first national historic site.

Stories of how Weir got his Branchville farm vary in the details from teller to teller, but there is no doubt that he acquired the property in an extraordinary way. Erwin Davis, the New York art collector for whom he had already bought Manets and other art, is said to have given the artist the farm in exchange for a Weir painting (some versions of the tale say it was a work by an Old Master). We should listen to Weir's own story, as he related it to Anna in a letter from New York posted June 15, 1882. The previous day, he wrote, he had visited a gallery, finding "a very fine picture which I could not resist the temptation of buying for which I paid $560 & last evening I had an offer for it from a gentleman who saw it, of the price and a farm of 150 acres in Connecticut." The proposal was too intriguing for him to ignore: "I will therefore try and see the place when I go to see my family, if not too much out of the way."[24] Coincidentally, his family was vacationing in nearby Ridgefield just then.

It is just a bit odd that Weir did not name Davis in his letter to Anna, since she knew very well who Erwin Davis was, and he was vague again when he wrote her on July 12 that the deed to the Connecticut property could not be signed that day because "one of the owners was out of town."[25] Town records, however, confirm that the owners were Erwin Davis and his wife Emily.[26] Weir paid the Davises the token sum of ten dollars when the property was deeded to him on July 19, 1882 (fig. 2). If Davis gave Weir $560 for a painting, in addition to the farm, there is no indication of it in the official property transfer. But payment for the painting may have been privately

[21] JAW to ADB, Aug. 5, 1882; JAW Papers, AAA, roll 125.

[22] JAW to ADB, Oct. 31, 1882; JAW Papers, AAA, roll 125.

[23] John Henry Twachtman to JAW, {1882}; JAW Papers, AAA, roll 125.

[24] JAW to ADB, June 15, 1882; JAW Papers, AAA, roll 125.

[25] JAW to ADB, July 12, 1882; JAW Papers, AAA, roll 125.

[26] I am grateful to Constance Evans, Director, Weir Farm Heritage Trust, for searching records at Ridgefield Town Hall for this information.

Fig. 2
The house at Weir Farm, Branchville, Connecticut,
before 1900 (Weir Farm Heritage Trust).

made, Weir may have been mistaken about the terms of the offer, or an original agreement that Davis would give Weir $560 *and* the farm might have changed.

Although Weir did not at first know that Branchville was a part of Ridgefield township, he already knew something of Ridgefield. Anna wrote him while his family was staying there: "I have thought of you often today as enjoying yourself at Ridgefield, and surrounded once again with those green hills and fields of which you are so fond."[27] The Weir family's presence there in June 1882 made it convenient for Weir to look at the Branchville farm ("grown" to 155 acres in his June 17 letter to Anna). If he thought it suitable, he told her, "we might have that as a sort of hunting lodge for part of the season."[28] This was the same summer in which the Adirondacks lodge held most of his attention. The deed to the Connecticut place reached him in Keene Valley in mid-August, and though he tried to buy a horse and cart for what he called his estate of rocks at Branchville and decided to evict the tenants so that repairs could begin, the Adirondacks house was still, to his mind, his future summer home. He exulted when he found twelve large iron nails from Toledo, Spain, for the front door, and one of his first purchases back in New York in the fall was an antique Dutch table for the mountain lodge. Still, a few days after that, he wrote Anna that he was sending some Alderney cattle to Branchville and would try to get a couple of carpenters to make repairs. It would be fun, he mused, to supervise the work himself.[29]

[27] *ADB to JAW, {June, 1882}; JAW Papers, AAA, roll 125.*

[28] *JAW to ADB, June 17, 1882; JAW Papers, AAA, roll 125.*

[29] *JAW to ADB, Oct. 22, 1882; JAW Papers, AAA, roll 125.*

Weir and Anna were married in New York on April 24, 1883. Before setting off for their European honeymoon, they spent several weeks at the house in Branchville. At least some of Weir's belongings were installed there, because his half-brother, artist John Ferguson Weir (1841-1926), eleven years older and director of the Yale Art School, lived there with his family that summer and spoke of writing letters at Weir's desk in the sitting room. While John was overseeing some renovations, he and others were receiving letters from Weir that pined for Branchville with an intensity that must have surprised them. Weir had planned a six-month tour of Europe, but almost from the start he wrote that he and Anna were aching for "the quiet plain little house among the rocks."[30] All the while, however, they were buying old window glass, an antique lock, brassware, furniture, and other treasures for their future homes in the Adirondacks and in New York. In Dresden, they got "one or two modest tablecloths for Branchville, as long as we were here," as Anna put it to her sister Ella.[31]

In late summer Weir received a letter from John that overflowed with praise for the "simply charming" Branchville farm, "in every way delightful." It was headed with an epigraph: "Here shall we rest and call *content* our home." Never shy about advising his younger brother, John told Weir to

> hang on to this place, old boy, a "lonesome lodge" which is a pleasant place
> of retreat in storm and drought—is no bad thing to have—for an artist—
> keep it trim and untrammelled, and you will find it a haven of refuge.[32]

Weir and Anna cut short their honeymoon and were back in America by October. It was more than longing for the Branchville farm that prompted their change of plans. Stories of a depressed art market in America had disturbed Weir, and he decided it would be prudent to return to "hammer at portraits." He did so very successfully in the 1880s and also produced a series of still lifes that were widely praised. He and Anna moved first into a small apartment on East 10th Street, near his studio in the Benedick Building at Washington Square, and then, two years later, into a townhouse at 11 East 12th Street, where Weir would live and work for twenty-two years. The beautiful things bought on the wedding trip gave the rooms both in New York and in Branchville a rich, eclectic look—deliberately less "decorated" than the Louis Comfort Tiffany interiors that were high fashion, but with antique furniture from various places and periods, and specially crafted touches like blue ceilings with gold stars.[33] His collections of Chinese porcelains, Venetian glass, Dutch tankards, and brass pots not only decorated Weir's houses but appear in many of his paintings.

[30] *JAW to his mother-in-law, Aug. 26, 1883; JAW Papers, AAA, roll 125.*

[31] *ADB {to Ella Baker}, Aug. 15, 1883; JAW Papers, AAA, roll 125.*

[32] *John Ferguson Weir to JAW, Aug. 2, 1883, JAW Papers, AAA, roll 125. J. Alden Weir liked the thought so much that later Stanford White painted the epigraph over the front door of the house (Young, p. 161).*

[33] *Caroline Weir Ely, 11 East 12th Street, New York (privately printed, 1969), unpaged pamphlet.*

At Branchville, where he and Anna began staying from May to late fall, Weir painted rooms, bought turkeys and ducks, pined for Holstein cows that he saw at the Danbury Fair but could not afford, and proudly surveyed his barrels of cider, bushels of potatoes, and barn full of grain. He had farm help, but he harvested corn and brought in the hay alongside the workers. He may well have agreed with his brother John, who said that the best days at Branchville were those with farm work all morning, painting all afternoon, and a good dinner between. Though a gentleman farmer, Weir believed the skim milk to be as essential an ingredient of farm life as the cream, so he studied farming as enthusiastically as he did Old Master paintings and Japanese art. For some time, however, he fretted that he was working so hard on the farm that little painting was getting done. His studio at Branchville was not finished until 1885.[34] He stretched his financial resources to the limit to build an addition (to the house? the barn?) in 1888.[35] Meantime, he was hoping to clear the farm of its ubiquitous New England rocks and make it pay its way. The summer of 1888 found him very short of money, grateful that at least the vegetable garden was thriving and that his fields were rich with grains and grasses.

Since his marriage, Weir had been finding nearly all his subjects, apart from portrait commissions, at home. Despite his abiding love of nature, for several years he seemed more interested in painting interior scenes with Anna, his daughters Caro (born 1884) and Dorothy (born 1890), and the family's numerous pets than in depicting the countryside at Branchville. He was perfectly aware of this and in 1887 sent Ella Baker a list of recent works in which he had portrayed her sister and a daughter, "so you see the household plays an important part."[36] This is the period of such fine works as *Against the Window,* 1884; *A Reverie,* 1886; *Anna Sewing,* 1885 (pl. 2); *Caro,* 1887 (pl. 12); and *Anna with Gyp in Her Lap,* 1890. Creating mood with a dark palette and exploring the penetration of sunlight into interiors seemed especially interesting to Weir in this period. *Lengthening Shadows,* a well-known landscape of 1887 (pl. 3), is a beautiful and remarkable exception to the domestic scenes. The view may be one that Weir knew at Branchville, but the swoop of the road, the tremulous look of the trio of saplings, and the pattern of light and shadow are exaggerated beyond anything to be found there. Afterward Weir would generally "bury" design more, as in *Early Spring at Branchville,* 1888-90 (pl. 6), where the hill and road are compositional devices as surely as their counterparts in *Lengthening Shadows,* but the look is more relaxed, with color, light, and atmosphere softer, more evanescent, and more suggestive of a particular place.

[34] *JAW to Ella Baker, July 7, 1885; JAW Papers, AAA, roll 125.*

[35] *JAW to JFW, July 1888; JAW Papers, AAA, roll 125.*

[36] *JAW to Ella Baker, Jan. 4, 1887; Weir Family Papers, MSS 511 (box 3, folder 5), Division of Archives and Manuscripts, Harold B. Lee Library, Brigham Young University, Provo, Utah.*

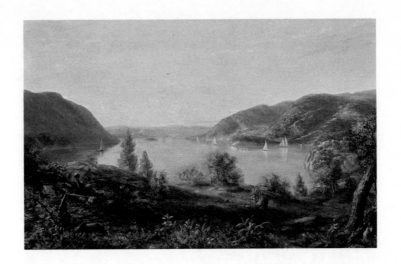

Fig 3.
J. Alden Weir, View of the Hudson River,
1870, oil on canvas, 24 x 32½ in., initialed and
dated lower left (location unknown).

Since Weir loved nature from boyhood, it is surprising that he did not embrace landscape art until the latter part of the 1880s. By then he was nearly forty years old and had owned the Branchville farm for some half-dozen years. He had, in fact, tried landscape in his youth. Predictably, given his attachment to family and to home ground, a painting of 1870 has as its subject a view of the Hudson River and is strikingly similar to one of his father's works (fig. 3). In France, Holland, and Spain, on holiday from the Ecole des Beaux-Arts, Weir sketched and painted a few landscapes, wanting to learn, as he told his parents, "to see nature simply." His training in Paris with Gérôme was typical in that it had little instruction in landscape, but Weir won compliments from his teacher on landscapes that he showed him. Since he expected to have to paint portraits to earn a living, Weir was satisfied with the emphasis that the Ecole placed on the human figure. When Weir spoke of studying nature in this period, he was as often referring to the entire world of living things as to the landscape.

Weir may have needed a great deal of time in a place before he could feel close to it. Branchville and Windham had different scenery from that at West Point, and they were, besides, different from one another. Weir's first Connecticut landscapes were of Branchville. It would be a few years more before he would depict scenes in Windham, where he went regularly but stayed for shorter periods. Weir's preference for familiar subject matter would explain why he grew to dislike portrait commissions and why his best portraits are usually of family and friends. In 1893 Hamlin Garland, in the

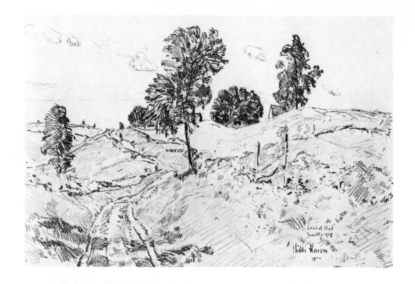

Fig. 4
Childe Hassam, Landscape, Land of Nod,
1918, lithograph, 8¾ x 14 in., signed and dated
on plate; signed with monogram in pencil
(Library of Congress).

first major defense of Impressionism in America, said that tourists cannot paint landscape.[37] Weir was of the same mind:

> One of my best landscapes was a clump of old trees standing down in the corner of my place in Connecticut. Now I had seen those old trees year after year until they had become a part of me, so to speak. One day the impulse seized me to paint them, and the picture instantly 'caught on.' This proves to my mind that you must make a subject a part of yourself before you can properly express it to others.[38]

It is abundantly clear that Weir enjoyed nature for its own sake and for its restorative powers. He told people that he loved hunting and fishing because they brought him closer to nature. Sometimes he went to Branchville or to Windham simply for a few days' loaf or even a day-long walk, and there are frequent references to Branchville and Windham as retreats from the world's hurly-burly. Weir and his friends were delighted at the serendipity of the Branchville house being on a hill called Nod, namesake of the legendary land of pleasant dreams (fig. 4). Weir's love of nature is evident in his landscape art, and in his letters, yet it is difficult to gain a clear understanding of how he regarded Nature on a philosophical level.

His friend Col. C.E.S. Wood thought of him as a pantheist, a label one might dismiss as figurative had Weir grown up in a different family. In the household of Robert W. Weir, Ralph Waldo Emerson and his creed of transcendentalism were well known and even revered, despite the elder Weir's Presbyterian affiliation. Regular

[37] *Hamlin Garland, Crumbling Idols: Twelve Essays Dealing Chiefly With Art and Literature (Cambridge: Belknap Press of Harvard University, 1960; 1st ed. 1894).*

[38] *J{oseph} Walker McSpadden, Famous Painters of America (New York: Dodd, Mead & Co., 1916), pp. 388-89.*

visitors to the family home included the artists Thomas Cole and Asher Durand and the poet William Cullen Bryant. There is no doubt that they believed, with Emerson, that they would "never see Christianity from the catechism," but "from the pastures, from a boat in the pond, from amidst the songs of the wood-birds, we possibly may."[39] In essays of the late 1830s and early '40s such as "Self-reliance," "Nature," and "The Over-soul," Emerson had touched them and many others of their generation by his faith in the integrity of the individual, the joys and spiritual significance of nature, and a deity in the universe with which each human soul could aspire to commune. The glowing light in the landscape paintings of Cole, Church, and others of the Hudson River School, as well as in Luminist paintings like those of Fitz Hugh Lane, represents that communion. Emerson was at the height of his powers at mid-century, when Julian Weir was only an infant, but his influence actually widened in the third quarter, largely because of Henry David Thoreau, who became the greater hero for many. Weir, however, was so familiar with Emerson's essays that Anna jokingly referred to "your friend Emerson," and she herself read him, possibly at Weir's suggestion.[40] Whether Weir was altogether persuaded by Emerson that the study of nature leads to Revelation is questionable. By the 1880s, Emerson's pure transcendentalism may well have been transformed by the public into something more sentimental. Yet Weir, a churchgoer, keeper of the sabbath, and Bible reader all his life, certainly believed that nature was the creation of God. And his comment to young Alden Twachtman that the little stream on Round Hill Road would teach the boy about the stream of life recalls one that Asher Durand made forty years earlier to his hypothetical student in the second *Crayon* letter (January 17, 1855):

> There is yet another motive for referring you to the study of Nature
> early—its influence on the mind and heart. The external appearance of
> this our dwelling-place, apart from its wondrous structure and functions
> that minister to our well-being is fraught with lessons of high and holy
> meaning, only surpassed by the light of Revelation.[41]

Interestingly, John Ferguson Weir, Julian's artist brother, grappled with the issue of Revelation, as did most other thinkers in an era that felt the need to reconcile new scientific findings and evolution theories with Christian theology. He published books on the subject: *The Way: The Nature and Means of Revelation*, 1889; and *Human Destiny in the Light of Revelation*, 1903.[42] They are not volumes that lend themselves to easy summary, but essentially they argue that God created nature, that there is a unity in nature which is affirmed by modern science, and, most importantly, that Spirit, or the supernatural, is indeed *supra*, above or behind nature. John Weir had

[39] *Ralph Waldo Emerson, Circles, quoted in Barbara Novak, Nature and Culture: American Landscape Painting 1825-1875 (New York: Oxford University Press, 1980, p. 7).*

[40] *ADB to JAW, May 26, 1882; JAW Papers, AAA, roll 125.*

[41] *Asher Durand, "Letters," Letter II, Crayon I (Jan. 17, 1855): 34.*

[42] *John Ferguson Weir, The Way: The Nature and Means of Revelation (Boston: Houghton, Mifflin & Co., 1889; 2nd ed. New York and London: G.P. Putnam's Sons, 1916); Human Destiny in the Light of Revelation (Boston: Houghton, Mifflin & Co., 1903). The citation in the National Union Catalogue (Library of Congress) for The Way notes that the author (unnamed in the citation) also wrote an introduction to and edited Revelation and the Life to Come.*

come to the conclusion that "the revelation of God as Spirit is in a sense distinct from his revelation in Nature as the creator and sustainer of the universe."[43] In his view, a student of nature may see the unity and harmony of God's creation, but only a soul "born of God" can commune with the deity. John Ferguson Weir had developed his basic philosophy by 1889. How much his younger brother was influenced by his thinking has yet to be determined. J. Alden Weir was in distress at this very time and would not soon be relieved of it.

In April 1889, when he wrote John that he was reading "your book," he and Anna were also reading "Swedenborg's work with the preface by Mr. Bigelow," another volume called *Spiritual World*, and "several others which have given us much pleasure and comfort."[44] They were both in desperate need of comfort. Their thirteen-month-old son (born 1887) had died the month before after only a few days' illness. Weir's father lay critically ill and would die in May.

Swedenborg's theory that every material thing has a corresponding "spiritual form" had caught the imagination of many an Eastern intellectual after the Civil War, and so had the doctrine of spiritualism. As early as 1882, Weir had gone with artist Eastman Johnson to see what a seance was like and been amused that the medium would not participate because Johnson refused to give his name.[45] Ten years later, however, he went as a grief-stricken widower anxious to make contact with the spirit of his beloved wife Anna. She had died February 8, 1892, a few days after giving birth to their third daughter, Cora. He tried seances at least twice then, but they were not satisfying. John urged him rather to "commune with the heart, then you choose your own companions."[46] Moreover, John was convinced by what he had been told that Weir had himself had a revelation experience in his wife's final moments, and there are hints that Weir thought so too.[47] Yet Anna's death was undoubtedly the low point of his life.

For a time Weir avoided Branchville entirely. The place that had become so dear to him was inextricably entwined with memories of Anna, and those memories were excruciatingly painful to him, although other family members were finding solace at Branchville. His sister Mary and her family spent time at the farm in the summer of 1892, when Weir was in Chicago working on a mural for the World's Columbian Exposition, and Mary wrote of Anna: "I often feel her presence and am sure that she is pleased that we all love her home so dearly and hold as most sacred all that has been sanctified by her love and yours."[48] A year later, Weir was still avoiding the farm, afraid even to look at storm damage to poplars that he and Anna had planted, because "to me they were so closely identified with her."[49] John was very concerned. "Cling

[43] J.F. Weir, *Human Destiny in the Light of Revelation*, p. 14.

[44] JAW to JFW, April 18, 1889; JAW Papers, AAA, roll 125.

[45] JAW to JFW, {1882}; JAW Papers, AAA, roll 125.

[46] JFW to JAW, May 21, 1892; JAW Papers, AAA, roll 125.

[47] JFW to JAW, Monday evening, {date?}, 1892; JAW Papers, AAA, roll 125. The content of this letter indicates that it was written soon after Anna Weir's death on February 8, perhaps even the next day. John speaks at some length of a "heavenly vision" that J. Alden has seen and of the "holy calm" that he experienced as a result.

[48] Mary (JAW's sister) to JAW, Sept. 1, 1892; JAW Papers, AAA, roll 125.

[49] JAW to Ella Baker, Aug. 28, 1893; JAW Papers, AAA, roll 125.

to this dear old place," he advised, "put even more of your affection in it—work out your thoughts and your life with this as a solace and a refuge." He offered as example his own family's response to a recent stay:

> All felt the sacredness of that affection which has consecrated not only your country home, but all the surrounding hills and valleys that were so dear to you both—I have thought that perhaps Anna was often in spirit still associated with many happy hours here, where all awakened such memories, and where all was still sacred, consecrated by loving hearts in sympathy with you both.[50]

J. Alden Weir was finally ready to agree. He had begun to mend over time, as his brotherly affection for Anna's older sister Ella deepened. She had cared for his daughters while he was painting his mural in Chicago. They shared a love for Anna and the children, had many of the same interests, and were much the same age. In October 1893, they married, and Weir began to enjoy nature again and take new pleasure in the places that were and had been peopled by those he loved best. Memories are not ghosts, however, and if Weir's interest in Swedenborg and spiritualism continued for long, signs of it have yet to emerge. But his new marriage created a strong link between his past and his present.

Anna died when Weir's art was undergoing great change. Two or three years earlier, Weir had announced his determination to stop seeing through the eyes of other artists and paint his own vision of nature. He had been saying much the same thing since his student days, but he seemed now to mean something new. In this period, a friend stood with Weir before a painting he had done a few years earlier and was shocked to hear him exclaim, "How could I have done it?"[51] His art was looking different. From about 1889, when he turned to landscape work, his colors were lighter, and he was employing new techniques that appeared strange, or even crude, to many viewers. Critics would soon begin calling him an Impressionist, often in derision, and John Ferguson Weir would all but call him fool. Weir did not care. He had been restricted, he said, by preconceived notions of how something should be seen. Now he was working to get *character* and *aspect: character*, the special qualities that distinguish something from everything else; and *aspect*, the way in which one views a subject in one's mind and feels it in one's soul. Discovery of the big truth, as he termed it, allowed him to take pleasure ever afterward in studying any phase of nature, because he saw the truth of which he spoke everywhere. Although Weir had all his life loved everything he had seen in nature, from the river valley of his youth to the French countryside to the rocky farmland of Branchville and Windham, he

[50] *JFW to JAW, Oct. 2, 1893; JAW Papers, AAA, roll 125.*

[51] *Howard Russell Butler, "The Field of Art: J. Alden Weir," Scribner's Magazine 59 (Jan. 1916): 131.*

seemed now to feel that capturing the look of the land in ways that express "that wonderful something that the landscape in nature suggests, somewhat like the soul of a human being" required new study and new ways of picture-making.[52]

He knew that his new path would not be quick and easy. His art looked different than before, but, in its philosophy, it was distinct from his earlier work only in subtle, elusive ways. As early as 1876, while he was still at school abroad, he had been studying nature, as he reported to his parents:

> I am learning to see nature simply and to place the tone as near as possible at the first start, studying each brush mark, and abhorring nothing that I see, but that all should hold its place in the grand mass—that a sharp line must be rendered sharp, and that a stone must be painted different from mud—in fact, each object has its own values.[53]

Then, he seemed intent on learning the meaning of nature as it was revealed through its appearance. By the late 1880s, his study seemed to focus rather on its invisible essence.

In any case, he was more interested in landscape painting than before, and issues confronted him now that had probably not arisen in portraiture and still-life painting, where he controlled the arrangement of people, furniture, and flowers. Landscape was different. "Arranging" landscape beyond a certain point distorts truth, as he seemed to define it. Push too far the abstraction that represents the underlying order of a scene in nature, then no matter how truly the *spirit* of place is conveyed, the illusion that one is viewing a particular place will be lost. Art that faithfully reproduces what one sees with the eye, on the other hand, is likely to overlook the essence, which Weir could not do without. In order to create art that synthesizes the specific and the universal, Weir believed that he had to learn more from nature, as he told his friend Wood in a letter in 1902. It was the essence, the spirit of place, that he seemed to feel the need to know better.

> I think that the canvasses I have have a more consistent truth. I have not changed in any way not even in the subjects chosen but it is my hope and desire to get close to Nature, to know her character more intimately, but I will be old, old, old before I can do even the little I do without her assistance.[54]

More even than his good friend Twachtman, Weir found his subject matter on home ground. Neither of them were innovators in this respect. As the nineteenth century progressed, American landscape artists, like their fellows in Europe, were

[52] *JAW to C.E.S. Wood, Jan. 4, 1899; JAW Papers, AAA, roll 125.*

[53] *JAW to his parents, Oct. 9, 1876; in Young, p. 108.*

[54] *JAW to Wood, Nov. 30, 1902; JAW Papers, AAA, roll 125.*

30

depicting ever smaller and humbler scenes. The extravaganzas of Bierstadt and Church had fallen from favor by Weir's time. The American public generally was less inclined to be awestruck by wondrous scenery. Nature writer John C. Van Dyke (who was also an art critic who consistently praised Weir) raised no furor in an 1898 book when he reviled a formerly precious American symbol, Niagara Falls, as "a great horror of nature."[55] The humble things of the earth are the real treasures, he wrote, such as the "very commonplace" ten-acre pasture:

> The quaint lines, the warmth and glow of color, and, above all, the broad area of sunlight, affect one emotionally. Take any man from the bustle of the city and place him there and he will instinctively breathe deeper, and though he may say little, yet be sure he is making confession in his secret soul—confessing to a feeling he cannot define.[56]

Such words could describe *Upland Pasture* (pl. 13), though that picture would not be painted for several more years (c. 1905). Yet Van Dyke knew other Weir landscapes, and he perceived Weir's skill at transforming common and even ugly subjects into "objects of beauty—forms seen in decorative color-pattern through a body of atmosphere and light."[57] Weir met the goal that Van Dyke had set for American landscapists in his *Art for Art's Sake*, a book of 1893: "To discover and interpret the delicate meaning in the humblest things about us . . . to make us see what the artist sees, and feel what he feels."[58]

Giles Edgerton, another contemporary critic, listed the subjects in current American landscape art that were sure to "bring quivering response," but Weir's are almost never these.[59] Not for him were isolated farmhouses, dories in twilight seas, or hidden pools in the forest, but rather farmland or village or woods where people worked and played. He knew that his subjects did not appeal to others. He was told it often enough. Critics sometimes agreed that he had made "the hopelessly prosaic mills" of Willimantic, Connecticut, delightful in *Factory Village*, 1897 (pl. 14), but collectors balked at buying factory or barn scenes for their living rooms, and critics who saw the poetry in *The Red Bridge*, c. 1895 (pl. 7) still chafed at the "disagreeable" red lead color. That color, it has often been noted, was true to life, since Weir painted the iron bridge just after its prime coat had been applied. Yet other colors and other elements in *The Red Bridge* are not as he would have seen them at the edge of the Shetucket River in Windham, where this work was painted.

How close are Weir's landscapes to what meets the eye? Surprisingly, perhaps, since his works evoke the specific even as they search for the universal, his painting

[55] John C. Van Dyke, *Nature for Its Own Sake: First Studies in Natural Appearances* (New York: Scribner's Sons, 1898), p. 170. This book was bought for the library of Storrs Agricultural College (forerunner of The University of Connecticut) the year it was published.

[56] Van Dyke, *Nature for Its Own Sake,* pp. 282-83.

[57] Van Dyke, "Ten American Painters," *New York Evening Post,* April 1, 1898, p. 7.

[58] Van Dyke, *Art for Art's Sake* (New York: Scribner's Sons, 1893), p. 27.

[59] Giles Edgerton, "American Painters of Outdoors: Their Rank and Their Success," *The Craftsman* (June 1909): 282.

sites are hard to find, especially at Branchville, where so many of his scenes were painted. Attempts to identify the hillside and boulders that form *Upland Pasture*, for instance, have always failed, though Weir Farm has been remarkably untouched through the years. Stone walls still line the landscape there, but deciding which opening in which wall was *The Open Barway* has thus far been an exercise in futility. Painting sites which have been identified, however, offer a glimpse into Weir's artistry.

In his personal papers at the Archives of American Art is a faded photograph of the site of *The Laundry, Branchville*, c. 1894, which one can find behind Weir's house today (see fig. 5).[60] In the photograph, clotheslines hang where one sees them in the painting, but these lines sag and are empty, except for a single towel on a short line at the left that veers off from the others. As in the painting, two ropes go from one tree to another, and a third tree stands before them. A house and porch railing can be glimpsed at the back of the scene. In the old photograph, a doghouse is near the house at the left, almost at the point where the clotheslines meet. (The doghouse in the recent photograph looks to be in much the same place.) More prominent than the tree in the middle is one farther back, to the right of the house (still alive, as the contemporary photograph shows), and a stone wall is there as well. A tiny sapling is in the foreground at the left. In the middle ground of the old picture, just right of center, are figures that are hard to make out, but they are probably two little girls, with what may be animals or birds at their feet.

The look is messy. The scene is without charm, even for a snapshot. One wonders what would move someone to take such a picture. Weir took a camera to Spain with him in his student days in order to take notes for his art, and Ella liked to use a camera, but if Weir, like his friend Theodore Robinson, had a habit of using photographs as an aid to creating his art, there has been no sign of it.

Here, however, is a rare opportunity to see something of how Weir turned a mundane scene into a painting. Most obviously, he added towels or whatever they are to the laundry lines, and he undoubtedly heightened colors throughout, although they are based on reality (the house was really red). There are major changes in point of view and in composition. The viewer sees the photographed scene at a distance and almost at eye level. In the painting, Weir raised the relatively flat level of the ground to a fairly steep hill, accentuating it with a streak of tan paint that suggests a path, no sign of which is in the old photo. One views the painting from a closer point than the photograph and looks down upon the painted scene and then up the hill.

[60] *J. Alden Weir Papers, Archives of American Art, roll 125, frame 478.*

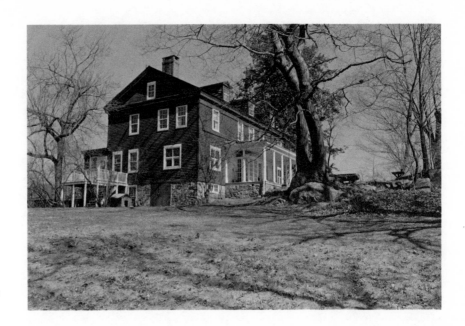

Weir omitted the tiny sapling in the foreground and "planted" two taller ones farther left, where they intensify the rhythms of the verticals that were already on the site. He also drastically changed the configuration of the house. Smaller then by half than it is now (the 1900 addition by noted architect Charles Platt juts towards us in the Garner photograph), the house has been "stretched" in the painting, by lean-to "additions" or adjacent sheds, so that it takes up most of the horizon line. Weir has also angled the house so that we see more of the gray roof than would be possible from our vantage point.

Weir recognized in the real scene the potential of shaping a dominant white triangular form from laundry hanging on a pair of lines. He saw, too, that he could create a lively ambiguity by moving the forward clothesline nearer to the viewer so that it looks as though it could be attached to the golden-leafed tree in the middle. Had towels been on the clotheslines as they appear in the photograph, they would have formed a pair of shallow arcs, with the towels on the rear line half blocked from view by the ones in front.

A comparison of *Factory Village*, 1897 (pl. 14), at the Metropolitan Museum of Art, with *Willimantic, Connecticut*, 1903, a painting in the collection of Arizona State University, and even with the Brooklyn Museum's *Willimantic Thread Factory*, 1893

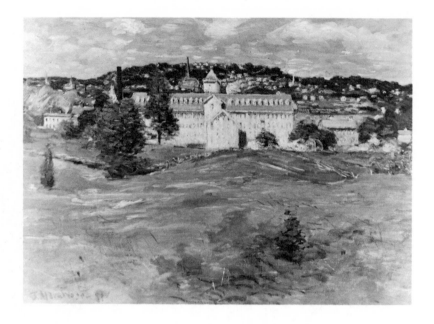

(fig. 6) , makes it clear that Weir changed, omitted, or added details in order to make
art out of a scene before him. The Metropolitan Museum and Arizona paintings are
similar, though the artist moved his outlook to the right in the latter. The mills in
Willimantic were, we know, in front of Weir when he was painting them. Not only
had he painted *en plein air* since the late 1880s, but his daughter Cora remembered her
father loading up the wagon with canvas and painting equipment to make the two or
three mile trip from Windham Center to Willimantic. "Pa loved those mills," she
said. But look closely at his paintings of them and see the mill's chimney change in
size from one to another. Houses tucked into the hillside show up in one work but not
another, while church spires float from spot to spot. Weir was engaging in what he
liked to call "hollyhocking." If, to be good, a picture needed the introduction of a
hollyhock or some other new bit, or some moving about of what was already in a scene,
then hollyhocking was in order. Even so, the sense of place is so strong in these factory
paintings that people who live in Willimantic today recognize their city in them,
despite the many changes to the scene that have come with the years.

It should not be surprising that someone who revered nature as much as Weir
should sometimes rearrange it. His artistic concerns were primary. Even influential
landscape architects of his day believed that nature generally benefited from a little

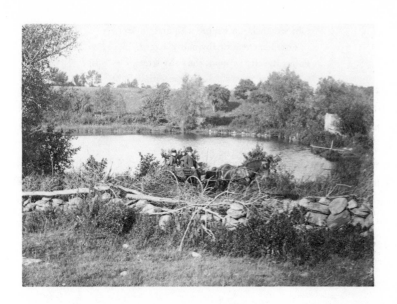

"improving," and indeed they often thought in terms of the principles of painting when they planned their designs. On his farm, Weir happily created gardens, moved rocks, and improved views by planting some trees and cutting down others, and when he won a Boston Art Club prize in 1896, he used the cash to create a large fishing pond (fig. 7). He did his rearranging of the real as well as the painted landscape with the thoughtfulness and sensitivity of a conservationist, in order to enhance nature, not spoil it.

Once Weir even moved a mountain. He could see the small mountain that he knew as Obweebetuck from the backyard of the Windham house, where he had first visited Anna (pl. 5). He and Ella eventually inherited the property. Behind the house is a washhouse that is partially visible in the painting. When one stands today on the spot where the artist would seem to have been at his easel, the mountain in his painting is much farther to the right than it is in reality. Nor can one see as much of it. That is true not because the view is now partially blocked by trees, but because, in the real landscape, the ground slopes upward towards the washhouse. Weir would have had to be at some distance above ground level to see the silhouette of the mountain as it appears in his painting. Despite the clear evidence of "hollyhocking," the picture *seems* right, even to people familiar with the real scene. Weir's view is peaceful and serene. Perhaps he knew the poem about Obweebetuck that a resident of Windham had composed for the town's bicentennial celebration in 1893. It begins:

Obweebetuck, once more with grateful feet,
　　I tread at eventide thy mossy height,
Forget the city's crowd, the noisy street,
　　And feast upon the landscape with delight.[61]

Enthusiastic hiker that he was, Weir had probably himself often feasted on the landscape from the mossy height. Today few people in the area know that the mountain has a name.

Weir spent much of the last summer of his life looking at Obweebetuck from a hammock in the backyard of the Windham house. He was so ill that he had to be carried to it by his farmhands. "What a beautiful world it is," his daughter heard him say as he lay there. He was speaking of Connecticut, his home ground.[62]

[61] "Obwebetuck," {sic} a poem by a "gifted son of the town," in A Memorial Volume of the Bi-Centennial Celebration of Windham (1893), p. 38.

[62] Quoted in Young, p. 260.

The Mystery of a New Path
The Art of J. Alden Weir

Helen K. Fusscas

"Of course, Mr. Chase's work is far more taking," wrote Clarence Cook about J. Alden Weir's art in 1878. "There is no difficulty in admiring that; but Mr. Weir's is not superficially attractive."[1] In recognizing that Weir's art is difficult for most viewers to appreciate, Cook identified a problem that has dogged the artist's reputation from that day to this. Weir's fame, his presidencies and prizes, his exhibitions and sales must have led people to expect his paintings to be lovely, easy to admire. Usually they were not. When Weir did paint a picture that was considered beautiful, he seldom repeated the subject or technique again. Most writers resorted to praising Weir for his very contrariness, as though contrariness were itself a virtue, as when Forbes Watson said, in 1914, "J. Alden Weir is one of those exceptional painters who have never retreated a step in order to please."[2] Skipping over paintings they did not like or understand, critics admired Weir's independence and the persistence with which he pursued "the mystery of a new path," as he called the challenge of trying something new in art.[3]

Recent critics have recognized Weir's importance as an American Impressionist painter. He was, after all, a founding member of The Ten, the group that came to be thought of as the core of Impressionism in America. Criticism of his painting, however, has been harsh. His soft gray-green palette has looked dull next to the dazzling intensity of Childe Hassam's. His application of color in bands or crude patches has seemed sadly ordinary beside the exquisitely sensitive paint handling of John Henry Twachtman. The fresh radiance of outdoor sunshine so evident in one of Willard Metcalf's paintings of a May day or an Edmund Tarbell orchard scene is muted and somber in Weir's empty pastures. Even today, Weir's career is sometimes characterized as lagging some ten or twenty years behind the work of the French artists who were its inspiration.[4] It is curious, then, that one of the most illustrated and discussed paintings in the literature of American Impressionism is *The Red Bridge*, c. 1895 (pl. 7). This Weir painting, done at the height of the artist's maturity, has long been considered a masterpiece of American Impressionist art.

Like many of Weir's works in the 1890s, *The Red Bridge* is a light-filled summer scene painted in high-keyed colors, with loose, informal brushwork. No children will

[1] Clarence Cook, New York Tribune, Mar. {date?}, 1878; quoted in Dorothy Weir Young, The Life and Letters of J. Alden Weir (New Haven: Yale University Press, 1960), p. 139.

[2] Forbes Watson, "J. Alden Weir," New York Evening Post Saturday Magazine, Mar. 28, 1914.

[3] J. Alden Weir, in a 1911 essay by Walter Pach originally published in the Gazette des Beaux-Arts, series 6 (Sept. 11, 1911); quoted in Young, p. 180.

[4] Doreen Bolger Burke, J. Alden Weir: An American Impressionist (Newark: University of Delaware Press, 1983), p. 15.

be seen playing in the water near a romantic-looking old bridge, however. Any such expectations are dashed at once by a glimpse through the trees of an uncompromisingly industrial red iron bridge. Then one's eyes are drawn, not by a dazzle of colored light as in most Impressionist paintings, but by the insistent structure of the painting's composition. Both intrusions, surprising in this context, seem oddly modern.

The red bridge dominates the picture. Weir placed it at the top of the canvas. Its bright color and strong-edged forms, however, project it forward so that we are made very much aware of the two-dimensional surface of the picture plane. The color and pattern of the bridge are reflected in the river in only a slightly paler version. The two bands of red patterning are tied together by a solid bar of color from the top of the canvas to the bottom, made up of the central red brace of the bridge and the front surface of the supporting pylon, which are then reversed in the reflection, with little reduction either in solidity or intensity of color. Around this vertical bar, the water and vegetation form triangles of light and shade—green, tan, and gray—that lock the surface into place and grid the canvas with the sharp diagonal lines of their edges. The rigidity of this structure is countered by the subdued natural curves of the monumental truncated tree branches that dominate the foreground. They run across the entire surface, cut off by every edge of the picture. Pushed up tightly against the surface of the canvas from a viewpoint that could not be encountered in reality, they contrast the softness of nature with the manmade grid, at the same time tacking all the forms to the two-dimensional canvas by forcing a single surface plane on the whole. The surface is further enriched by flat, bright green circlets of color, which dance around the perimeter, suggesting a dappling of leaves. The sense of surface composition is strengthened even more by the addition of calligraphic gray and black lines, delicate as spider webs, which define the flat blocks of color.

The importance of *The Red Bridge* is that, unlike other Impressionist paintings, it tackled the problem that was being posed by contemporary European artists: how to show a three-dimensional world without denying that a painting is a flat two-dimensional surface. The solution to this problem lies outside the traditional Renaissance theory that a painting is a window in a wall, which reproduces an illusion of distance through linear and aerial perspective and an illusion of three-dimensional form by modeling it with light and shade. Instead, an equivalent (though not literal) of what the eye sees is created through flat areas of color, surface lines, and composition, by which the artist expresses his response to what he sees. This concept freed painting from reproducing the visual world for the first time since the Renaissance and

prepared the way for modern abstraction. Paul Cézanne devoted his life to this issue,[5] and it is this issue that was explored by Gauguin, Bernard, and Serusier at Pont Aven, Brittany, in 1889, where an aesthetic solution was developed that in various forms dominated European art until Cubism.

One great success of *The Red Bridge* is that it resolves the aesthetic problems it poses instead of having the tentative quality of an experiment. Weir restricted the field of his subject, cutting off the distance by using a high bank behind the river to eliminate a vista. Instead of forcing geometry onto the landscape, he used the geometry of the bridge itself. The risk of this method is that at first glance the picture seems to represent visual rather than synthetic reality. It is easy to pass over its revolutionary qualities. It succeeds, however, as a painting that is modern in subject and technique, blending man and nature, industry and landscape into a satisfying, ordered harmony, by means of abstract composition. It is also a painting which transforms a commonplace American scene into poetry.

The American qualities of Weir's painting are particularly interesting. Although there was no recognizable American style during his career, there was a national character, and Weir's work reflected it. His down-to-earth backyard subject matter contrasted unmistakably with fashionable international norms, as did his simple, even crude, technical choices. European training and a sophisticated aesthetic underlay his images, but Weir chose to express traditional American values, such as the moral goodness of home, family, land, labor, and progress with a forthright honesty and no-frills directness that reflected the character of American society. Furthermore, his independent and self-reliant experimentation with new ways to express his ideas revealed a typical American attitude, which put faith in the individual over the group and required no one's approval to find unique and sometimes revolutionary solutions to problems.

Weir's second undisputed masterpiece of the mid-1890s is *The Factory Village* (pl. 14). This painting built on the ideas represented in *The Red Bridge* and carried them to a new, bolder level of expression. The subject of the painting is an identifiable view of a real factory village, Willimantic, Connecticut. Subtle distortions in the shape and scale of elements in the composition abstractly symbolize Weir's intent. There are two dominating verticals, the tree (nature) and the chimney (industry). The enormous tree, made flat and geometric to isolate it unobtrusively from reality, looms over the viewer from the left side of the painting. On the right is the chimney, dramatically enlarged in scale from its distant village surroundings and projected forward by its prominent reddish color. The space between the two is bridged by a branch of the tree

[5] *If Weir's work were to be compared with that of European Post-Impressionists at this time, it would have the closest relationship to Cézanne's work. Like Cézanne, Weir was interested in expressing the enduring structure underlying landscape, rather than its momentary reality. Cézanne's techniques, such as solidifying skies with the abstract branches of trees, vertical stacking of forms, high horizons, bold colors in the middle distance to project forms forward, no visually receding pathways, and no aerial perspective, are all found in Weir's work. Comparison with Cézanne's paintings is extremely interesting. See John Rewald, Cézanne (New York: Harry N. Abrams, Inc., 1986) and Meyer Schapiro, Cézanne (New York: Harry N. Abrams, Inc., 1988).*

which reaches across like an arm to "embrace" the chimney top. The chimney exudes a gray trail of smoke that mimics a small cloud above it, locking them into relationship by the similarity of their forms. By equating the smoke to the cloud, and the chimney to the tree, Weir reiterated his philosophy of the compatibility of nature and industry.

Other geometric shapes in the composition are repeated to strengthen the solidity of the surface and to re-emphasize the unity of the landscape and the village. The angle formed by the outer branches of the tree, for example, reappears in roof peaks and in the diamonds of sunlight and shadow in the pale green landscape in the middle distance. Surface unity is also enhanced by the densely packed patches of color: blue sky painted over the green leaves of the tree; pale and dark green vegetation; gray roofs and beige buildings. Artist Theodore Robinson aptly described one of Weir's views of these mills as "modern, yet curiously medieval," referring perhaps to the tapestry-like effect that results from the opaque colors that all seem to be on one plane.[6] Once again, the harmonious relationship of the village and nature, God's work and man's work, is expressed through the means of painting itself in an interlocking structure of shapes, colors, and patterns. At the same time, the painting remains a satisfying and beautiful portrait of one of Weir's favorite places.

The source of Weir's divergence from the style typical of trained, academic artists can be traced to his early student years. He had the unusual advantage of having both a father and an older half-brother who were noted American painters. Both men had worked during the height of pre-Civil War confidence in Americanism, when wealthy Americans had been happy to acquire American paintings, which reflected their pride in themselves and the romance and excitement inherent in the American landscape. J. Alden Weir's own early paintings followed the family tradition and expressed the same reverence for and appreciation of the spectacular natural scenery of his West Point home as did those of his father and brother (fig. 3). When post-Civil War Americans rejected the worth of American art in favor of European academic styles, the Weirs were not converted and continued to urge an American perspective on J. Alden. While his family encouraged him to experience European art and to study in its schools, in order to ensure his commercial success, they also cautioned him against losing his individuality. When one of Weir's first major European paintings, *Interior—House in Brittany*, 1875 (fig. 8), reflected the tedious, overstudied work of the academic tradition, his artist brother John Ferguson Weir told him that the painting was pedestrian and reflected an effort to make a picture rather than express the character of nature. He did not mince words: "Now if study abroad leads to an adopted

[6] *Theodore Robinson's diaries, February 27, 1894; quoted in William H. Gerdts, American Impressionism (New York: Abbeville Press, 1984), p. 163. Robinson's diaries are at the Frick Art Reference Library in New York.*

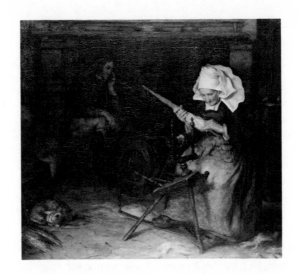

Fig. 8
J. Alden Weir, Interior–House in Brittany, *1875, oil on canvas, 29¾ x 32⅝ in., signed, dated, and inscribed at lower left: J. Alden Weir/Paris 1875 (private collection).*

manner, following in the footsteps of others, I think it certainly very pernicious. Don't lose individuality."[7]

Under this guidance, Weir began to divorce himself from his former academic style and to open himself up to new influences. In February 1876 he wrote to his brother:

> I want to be as *bête* as an infant of ten, by these rules of art one is constrained and *naiveté* is lost which to me is one of the greatest charms and which you will find that the old masters all endeavored to get. . . . To me therefore there are no rules except those which your own feelings suggest and he who renders nature to make one feel the sentiment of such, to me is the greatest man. I have within the past two years been trying to paint in a manner different from the way I now think and feel.[8]

With these words Weir ended a chapter of his life. He felt ready to look at the visual world with an independent mind and attempted to achieve a personal style of painting.

When Weir returned from his studies abroad in 1877, he was considered one of the leading young artists of the new European-trained breed. Earlier that year he had had five paintings accepted in New York's National Academy of Design exhibition, a sign of approval from the art establishment. He was also embraced by the more progressive elements in the New York City art world, the artists who had formed the new Society of American Artists, and he exhibited in their first exhibition in 1878. It is important

[7] *Letter to J. Alden Weir from John Ferguson Weir, April 17, 1875; in Young, p. 72.*

[8] *Young, p. 95.*

that his work there was singled out by the critic, Clarence Cook, who already recognized that Weir's art could not be considered in the same context as his peers. Cook wrote:

> One must have gone through with a good deal, have become tired of a good deal before he can take real pleasure in these low-toned, unkempt heads, and can recognize in their sureness of touch, singleness of aim, and absolute dependence on truthfulness, the spirit of a genuine artist. Apparently Mr. Weir cares very little as yet for beauty and less than nothing for what is known as "finish," but he does care for study, and he is bent on using his own eyes. . . . Since this exhibition opened, no work has attracted more serious attention than Mr. Weir's.[9]

Even at this early date, this perceptive critic pointed out qualities of Weir's work that would remain his most characteristic: it is not easily accessible; the technique is purposely simplified, even crude; it is an expression of the important truth or character of the subject instead of merely its visual appearance; and it is the result of a great deal of careful study, no matter how naive it might appear.

Weir's work needed to be explained. Many of his important early paintings were easy to overlook. For example, *Snowstorm in Mercer Street*, 1881 (fig. 9), is at first glance a nondescript gray winter street scene. Of minor interest are its loose brushstroke and its evocation of the damp chill of the falling snow, which suggest an awareness of the work of the *plein-air* Barbizon painters, or even of such French Impressionists as Pissarro.[10] This painting, however, already indicates Weir's interest in new paths.

The dominating element of the picture is a telephone pole that bisects the surface of the canvas from the sky to street. Wires emerging from the top of the pole terminate in midair. The building on the right appears to be well behind the pole but could be only a few feet away, while those at the left are dwarfed by the pole, although they are only on the other side of the street corner. What we are seeing is one scene in at least three different scales. Weir has discarded one-point perspective. He has concentrated instead on the surface composition of the scene, which is orchestrated by a rhythm of verticals and horizontals, with flat planes of dark colors to indicate buildings. Distance is denied. The receding street is blocked before it can penetrate space. A dark zigzag line runs up through the left quadrant of the sky, to counteract one's natural tendency to read that gray area as distance. This solidification of the sky is very modern and suggests that Weir already knew of Cézanne's work.

Weir's early interest in surface structure in such works as *Snowstorm in Mercer Street* also suggests a relationship to the work of Edouard Manet. Manet was similarly

[9] *Quoted in Young, p. 140.*

[10] *Weir admired the Barbizon painters, particularly after seeing an exhibition of their work at Durand-Ruel's gallery in Paris, August 1878. It was this show that convinced Weir that he should abandon the academic style of painting. See Young, pp. 143-44.*

interested in surface design, employed inconsistent scale, and disregarded Renaissance perspective, which were methods derived partly from his study of Japanese prints. In addition, Manet's elimination of halftones, the informal poses of his figures, and his wide, bold brushstrokes all appear to have had an impact on Weir, who knew and admired Manet's work. He had gone to a reception at Manet's studio in 1876, purchased two Manet paintings for the New York collector Erwin Davis at Durand-Ruel's Paris gallery in 1881, then visited the artist soon afterward and bought yet another. No mere imitator, however, Weir seems to have studied Manet's painting and adapted what was useful to him into his own idiom.

In 1881, Weir began a series of floral still lifes which were unusual. Compared with his still lifes dating from the late 1870s, such as *Still Life in the Studio*, c. 1877-80 (fig. 10), the slightly later works are revolutionary. While *Still Life in the Studio* shows still-life objects carefully set into lucid space and convincingly modeled, the paintings from the early 1880s often describe fantasy flowers with barely suggested forms, floating on a dark yet luminous ground. The flowers in the Thyssen-Bornemisza Collection are a case in point (*Silver Cup with Roses*, 1882). With the exception of the silver chalice in the background, the composition is made up of amorphous shapes of pale colors given a hint of "flowerness" by deft strokes of white-slaked pastel colored

paint. The scatter of abstract blue dots to the left and across the center suggest forget-me-nots or light motes but serve to decorate and define the surface, drawing the blues of the chalice forward into the design. Another fine example of Weir's flowers is *Silver Chalice, Ceramic Jar, and Vase*, which depicts lilacs, white peonies, and pansies (pl. 8). The peonies in this painting are alluded to with sure strokes of a palette knife, creating once again a conviction of flowers without illustrating them. Light is inherent in colors without shadows or highlights. Form is suggested by the overlap and angling of the strokes, not by modeling in light and dark. Composition is in the relationship of areas of light and dark on the surface of the canvas and not in the excavation of space. Probably because their subject was easy to enjoy and their experimental style easy to overlook, these flower paintings were instantly popular with the public. Typically, Weir was not seduced by their commercial success but moved on to other challenges.

Not all of Weir's experimental work was successful. *Carrie as Flora*, 1882 (fig. 11), for example, presents difficulties. Flora, a classical subject, conjures up images of maidens draped in classical robes heralding the arrival of spring. Carrie, however, is a stolid Victorian woman portrayed in a traditional way. The classical swag of flowers in the background highlights the folly of conceiving her as Flora. Stylistically there is also an unresolved dichotomy. Carrie's head is painted in dark tones with a firm outline. Although the brushwork is rough, with no shading, it is still traditional and contrasts jarringly with the shimmering background, scumbled collar, and palette-knifed flowers, which are painted with dazzling bravura. The flowers, which cascade

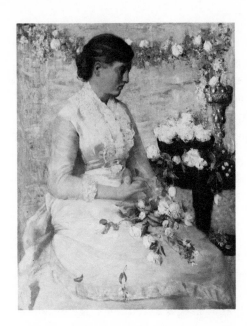

Fig. 11
J. Alden Weir, Flora (Carrie Mansfield Weir),
*1882, oil on canvas, 44 x 34 in., signed and
dated at upper left: J/Alden/Weir/–/1882
(Brigham Young University, Provo, Utah).*

down onto the table and into Carrie's lap, are the focus of the painting. Contemporary critics called the flowers bizarre and described them as "a repulsive mass of thick paint,"[11] but by today's standards they are one of the most beautiful and exciting passages in Weir's art. The flowers are almost three-dimensional in thickness, the paint creamy and moist, the colors a rich mix of yellows, whites, pinks, and lavenders. The tracks of the palette-knife are authoritative and bold.

Weir's technique seemed to change with each new painting. In some works he reduced his means to a few broad flat bands of color highlighted by obvious strokes of a palette knife. In others he adapted the broken brushwork of the Impressionists to the needs of his stronger two-dimensional structure. Sometimes he reverted to a more academic style, which puzzled his critics. He could at times achieve an enamel-like smoothness and polish with his palette knife, but other times he would apply thick dry paint to the surface with repeated vertical strokes of his brush or dig out great scratches of texture from a layer of color with the wooden end of a brush. At least once he used buttermilk to achieve an elusive white, and several times he used puddles of colored glazes to alter pigments.[12] Occasionally he was so experimental that few could appreciate his efforts.

One of Weir's most consistent and least understood attitudes towards technique was his dislike of "finish." He once told a young student to "throw away his brushes,

[11] *Dorothy Weir Young Papers, Mss 1291, box 3, folder I, p. 12, Department of Archives and Manuscripts, Harold B. Lee Library, Brigham Young University, Provo, Utah.*

[12] *Thomas Whipple Dunbar, "Julian Alden Weir, of Ever Increasing Fame," Art World Magazine, Jan. 13, 1925.*

go out in the country and paint with a stick—look at nature and get the paint on anyhow—try to get the character of the thing."[13] For Weir, technique was not a demonstration of an artist's skill but a tool for expressing the significance of a subject. Often he applied paint with deliberate simplicity or even crudeness. The result was less primitivism than refined reduction, which served his purposes well but confounded the press. In 1920, the highly-respected Boston art dealer, Robert C. Vose, however, summarized Weir's technique perceptively:

> He was not a technician, in the common acceptance of the term but, as compared with the facile cleverness of the average technician, his original and charming brush-work is as satisfying and as much a relief, as is the blunt sincerity of the statesman, who deals in facts and unerringly shows us the fundamental needs of the hour.[14]

Many of Weir's still-life and figure paintings from the middle 1880s demonstrate the continuing intensity of his experimentation. Some of the most beautiful of these are watercolor and gouache portraits of his wife, Anna, posed in front of a window in a dark interior. *Anna Sewing*, 1885 (pl. 2), is an especially harmonious composition. The main element of the structure is a vertical line running through the window, Anna's neck, and the center of her bodice. Slightly off-center, this line combines objects that are not in the same spatial plane, a compositional device that Weir repeated frequently. The horizontals are set by the crossbar of the window, the windowsill, the chair back, and the bench seat. Against these elements are composed the lovely diagonals and curves that complete the structure. The radiant fabric that Anna is sewing and the glowing white curtains behind her are set against the rich dark shadows of the interior, which themselves grow slowly luminous as one studies them. The two whites are connected by reflected light, which illuminates Anna's face, her buttons, the brass tacks of the bench, and the edge of the spindle-back chair. These highlights add tiny enriching accents to the dark areas.

The whole is marvelously convincing but is, in fact, highly unrealistic. The brilliant white of the fabric has no possible light source, and the reflected light on Anna's face, on the knob of the chair, and the face of the dog have no explanation. The radiance seems to be contained within the objects themselves, just as the dark seems to have a life of its own that is unrelated to natural shadow. The perspective is equally illogical, being abrupt and inconsistent. The knob of the chair, set parallel to the picture plane, looms out on a giant scale. Anna is set behind it and is small in comparison, yet her sewing lies on the arm of the chair and is in the same plane as she. Each element seems appliqued to the next, and the result is a spacelessness which

[13] *Young, p. 248.*

[14] *Memorial Exhibition of Paintings by J. Alden Weir, P.N.A. (exh. cat., Vose Galleries, Boston, May 3-22, 1920).*

emphasizes the forms and their relationships on the surface of the paper, rather than in the third dimension. The arrangements of light and dark and of vertical and horizontal create a balanced harmony so complete that they express in themselves the artist's feelings of the loveliness, beauty, and goodness of the scene.

A more complex resolution of the same aesthetic problems can be seen in *Anna and Caro in the Twelfth Street House* (pl. 9), done two years later, in 1887. Here again a vertical, not quite in the center of the picture, unifies elements from different spatial planes. Here also is the odd perspective, which allows us to look down from afar on the oblique little footstool in the foreground, directly across at Anna in her chair, and sharply up at little Caro looking out the window. Color forces one's eye to relate to the same plane the white curtains and the white book in Anna's lap, and the copper kettle in the foreground and the orange curtain in the background. The little girl and animal seem part of a vignette completely unrelated to the rest of the picture in space or scale.

In these watercolor and gouache paintings, with their subtle arrangements of form and their strong use of black, there is a substantial debt to the work of Whistler, who, along with Manet, must be considered a great influence on Weir's art. Weir had been well aware of Whistler's work. In a brief stint at West Point, Whistler had studied drawing with Julian's father, Robert W. Weir. Weir had visited Whistler in his London home in 1877, and again in 1881, where he saw the famous "Japanese" dining room and viewed Whistler's nocturnes, portraits, and etchings.[15] Very likely Weir saw *The White Girl: Symphony in White No. 1* when it was exhibited in New York in 1881, and he must have been aware of the *Arrangement in Gray and Black No 1: Portrait of The Painter's Mother*, which was exhibited at the Paris Salon in 1883, while he was in Europe on his honeymoon. Weir's still life, *Silver Chalice, Japanese Bronze, and Red Taper*, c. 1880-85 (fig. 12), is a tribute to Whistler, featuring the flat blocks of color, cropped views of objects, muted color harmonies, and decorative abstract composition that are common in Whistler's work. Whistler's signature and monogram are isolated against blank white in a prominent area of Weir's composition. This is no "School of Whistler" painting, however, because Weir's work demonstrates a robust appreciation of the essential qualities of the objects themselves, while Whistler's art expresses abstract poetic fantasies inspired by the objects before him but set free from them. The similarity between the two men is less their objectives than how they achieve them.

During the late 1880s, as his interest in flowers waned, Weir focused his attention on landscape painting for the first time since his youth. The qualities that made his still lifes and interiors remarkable also stamped his landscapes with originality. *Lengthening Shadows* (pl. 3), painted at Branchville in 1887, is a striking contrast to

[15] *Young, p. 147.*

47

Fig. 12
J. Alden Weir, Silver Chalice, Japanese Bronze, and Red Taper, *about 1880-85, oil on canvas, 17¼ x 11⅜ in., signed at upper right: J. Alden Weir (Hope Davis Fine Art, New York).*

the official art of the time. Weir submitted the painting to the Universal Exposition in Paris of 1889, an exhibition designed to show the world the great achievements of each participating country.[16] The importance of the fair was symbolized by the Eiffel Tower, a marvel of engineering that heralded a new age in architecture. In the fine arts, however, the fair was the last great hurrah for the conservative academic tradition. The French section included the huge classical compositions of the older French masters, who dominated the government-approved Salon exhibitions. The American section reflected the French section and demonstrated what American juries considered suitable for display on the continent. Weir found this ostentatious exhibition "tiresome" when he visited it and spent little time there.[17]

Weir's own landscape stood out in surprising aesthetic isolation from its surroundings. While most of the entries were large presentation pieces, Weir's was little more than one-and-one-half by two feet, almost insignificant. The subject of the painting was equally inconsequential and unsuitable for a display piece. It depicts a section of Connecticut pasture with a dirt road cleaving the hills. The scene is empty, despite a glimpse of a house perched on the horizon. No heroic laboring peasants or elegant city travellers on an outing are there to trigger romantic emotions or moralizing thoughts; no animals or even flowers to foster nostalgia or bucolic sentiment; no storm in the sky or lingering sunset to engage a sense of the sublime or the picturesque. This little New

[16] *This exhibition was reassembled in 1989 by The Pennsylvania Academy of Fine Arts. The accompanying catalogue is an excellent resource: Paris 1889: American Artists at the Universal Exposition. Another excellent book on American art exhibited in Europe is Lois Marie Fink, American Art at the Nineteenth-Century Paris Salons (National Museum of American Art, Smithsonian Institution, Washington and Cambridge University Press, 1990).*

[17] *D. W. Young Papers, Mss 1291, box 3, folder 6, Lee Library, BYU.*

England hillside, however, has the understated impact of an icon.

Lengthening Shadows is a conceptual rather than specific landscape. Its effect comes in part from an unnatural golden sunlight, which has distilled the scene and frozen it into reverential stillness. The effect is also partly the result of Weir's already typical vertical perspective, which places objects up rather than back in space and which denies aerial perspective by giving distant objects the same detail and rich coloring as closer ones, thereby suspending the illusion of reality. Most importantly, the effect is achieved by reducing the elements of the subject to simplified, abstract forms with smooth contours. Patterns of sun and shadow are given the same solidity as the objects themselves, and together the contours are repeated and varied rhythmically across the surface. The foreground and distance are tacked together on the surface of the canvas by the stark verticals of the sapling trees. The composition is once again so interlocking and resolved that one is struck by a classical sense of harmony in a completely new context. This is not a grandiose painting, nor a virtuoso one, nor one that captures a charming moment of nature. Instead, it is a painting that replaces a real landscape with an abstract landscape, expressive of Weir's understanding of the permanence and harmony underlying nature. *Lengthening Shadows*, condensed like a poem to essential elements, is a landscape of the mind.

At this time Weir's work had little to do with French Impressionism as exemplified in the art of Monet and Renoir. Although he had not been to France between 1883 and 1889, he was well aware of the work of these artists. He had encountered the Impressionists as a student in Paris in 1876 and rejected them in a famous letter home.[18] In New York a year later, however, he had encouraged Impressionist Mary Cassatt to exhibit with the Society of American Painters, which she did in 1879, entering *Le Figaro*.[19] Cassatt's Impressionism, though deeply allied with Degas, had many points in common with Weir's work, which drew upon the same sources of inspiration. In the 1880s, Weir's art had little interest in momentary views of reality and was not derived from Monet's research into the nature of light. Like Cassatt, Weir was indebted to Manet, Whistler, and the Japanese.

The most important opportunity that Weir and other artists had to see contemporary French art in America was the exhibition that the Parisian art dealer Durand-Ruel organized in New York in 1886.[20] It caused a sensation in the city, and Weir was so excited by it that he wrote his brother John, "This is the most interesting exhibition for an artist to see that we have yet had."[21] The Durand-Ruel show, which coincided with the last of the Impressionist exhibitions in Paris, not only displayed the work of the great masters of Impressionism but exhibited works that pointed to the end of

[18] *In a letter to his parents Apr. 15, 1877 (in Young, p. 123), Weir wrote: "I went across the river the other day to see an exhibition of the work of a new school which call themselves 'Impressionalists.' I never in my life saw more horrible things. . . . They do not observe drawing nor form but give you an impression of what they call nature. It was worse than the Chamber of Horrors, I was there about a quarter of an hour and left with a headache." It is important to put this comment in perspective, however, as Weir often disliked paintings on first contact that were later to have a great impact on his work.*

[19] *Gerdts, p. 34.*

[20] *Anne Distel, "The Markets for Impressionism Outside France: The United States," Impressionism: The First Collectors (New York: Harry N. Abrams, Inc., 1990), pp. 233-34.*

[21] *Young, p. 168.*

Impressionism and the beginning of a new era in Europe, Post-Impressionism.[22] For example, paintings by Seurat and Signac in the exhibition, although pre-Pointillist, were characterized by the solidification of forms and shadows into flat geometric patterns that could no longer be classified as Impressionist. Seurat's gigantic *Une Baignade* stood out in particular. Perhaps the new work in this exhibition had some influence on the austere geometry Weir developed in *Lengthening Shadows* the following year.

Three years later, when Weir returned to Paris for the International Exposition of 1889, both Impressionism and the new Post-Impressionism were much in evidence.[23] The work of the Impressionists, while still not widely accepted, no longer seemed revolutionary. The French had even hung works by Manet, Monet, and Pissarro in the Exposition. While the fair was on, several Parisian art dealers were showing Manet and the other Impressionists. Petit's Gallery had mounted a retrospective exhibition of 125 paintings by Monet, whose work in particular had begun to sell for significant amounts of money.

At the same time, avant-garde circles in Paris had begun to regard Impressionism as traditional. Key Impressionist painters were returning to some of the values they had cast off. Renoir reintroduced classical drawing into his figures, while Monet tightened composition, bringing more structure and decorative design to his canvases. Seurat and Signac had so altered Impressionism, with their new scientific theories of color and composition and their new technique of Pointillism, that the critic Felix Feneon dubbed them the New-Impressionists to distinguish them from the older generation.[24] Cézanne, Van Gogh, Redon, and Gauguin and his friends were making even more startling changes: their art used color and form in a new, flat, two-dimensional way to express the artist's experience of things by equivalents of experience, not by representations of the things experienced. This is the goal that Weir was himself working to achieve and that he mastered in the 1890s.

While Gauguin and Bernard did not have paintings admitted to the Paris Exposition of 1889, they exhibited at the Grand Café des Beaux-Arts, adjacent to the official art section of the Exposition.[25] They called their show, "Groupe Impressioniste and Synthetiste," an accurate expression of their dependence upon the discoveries of the former group and their revolutionary split from it. Weir is likely to have seen their exhibition, and since he was accustomed to making the rounds of the art dealers for his collector-clients, he probably saw the work by Gauguin, Van Gogh, Seurat, Signac, and Cézanne that was on view in Paris galleries at the time.[26]

When he returned from France that fall, Weir entered into an important period of

[22] *The history of these exhibitions and of the paintings in each one has been thoroughly studied in The New Painting: Impressionism 1874-1886 (exh. cat., The Fine Arts Museums of San Francisco, 1986).*

[23] *Two basic references on Impressionism and Post-Impressionism in Europe are John Rewald, The History of Impressionism (New York: Museum of Modern Art, 1973) and John Rewald, Post-Impressionism: From Van Gogh to Gauguin (New York: Museum of Modern Art, 1978). Also of importance are Rewald's Studies in Impressionism (New York: Harry N. Abrams, Inc., 1985) and Studies in Post-Impressionism (New York: Harry N. Abrams, Inc., 1986).*

[24] *Rewald, Post-Impressionism, p. 89.*

[25] *Rewald, Post-Impressionism, pp. 256-65.*

[26] *Dealers such as Durand-Ruel and Boussod, Valadon & Co. offered inventories of work by most of the Impressionists. That Weir was at Durand-Ruel's during this visit is documented by Burke, p. 191, who noted that he purchased a Puvis de Chavannes painting at that time. Durand-Ruel, also had work by younger artists on view, including Seurat and Signac, whose Neo-Impressionist theories were causing a sensation. Pere Tanguy, the art supply dealer at 14 Rue Clauzel, had paintings for sale in his window by Pissarro, Guillaumin, Gauguin, Van Gogh, Seurat, Signac, and Cézanne. Theo Van Gogh had obtained permission from Boussod, Valadon, where he worked, to exhibit the work of modern painters on the mezzanine of the shop. He displayed not only the work of Degas, Monet, and Pissarro, but also that of Gauguin and Vincent Van Gogh. See Rewald, "Theo Van Gogh as Art Dealer," Studies in Post-Impressionism, pp. 7-116.*

intense productivity and experimentation. His palette had begun to lighten even before his trip, and many paintings in his joint auction with Twachtman in February 1889 had looked "modern" to the critics. Not until his first one-man show at the Blakeslee Gallery in January 1891, however, did critics label Weir an Impressionist, although most of them knew so little of the aesthetics of Impressionism that they tended to call any painting with loose paint application and non-academic subject matter "Impressionist."

Weir's work was certainly moving in the direction of Impressionism. The golden light of *Lengthening Shadows* had given way to natural white light, outlines were broken up, and brushstrokes were loose and patchy, sometimes even approaching the small dabs that were typical of Monet. Even with this looser, sunnier work, Weir's search for the structure of nature and its expression on the two-dimensional surface of the canvas remained his primary concern. *The Lane*, c. 1890, with its pinwheel composition that centers on rocks in the upper right, *Early Moonrise*, 1891, where the landscape is layered in bands of different textures without shadows or recession and the sky is applied opaquely to the surface, and *The Grey Trellis*, 1891 (fig. 13), in which a charming impressionist scene is overlaid with a stark grid that denies visual access to space are paintings that each probe in a different direction. *Midday*, 1891 (pl. 16), telescopes the foreground and middle ground without transition and gives shadows and tree branches equal solidity. *Anna Seated Outdoors*, 1891, offers large blocks of

color laid out on the surface, each with an experimental texture: her dress thick paint plastered with the palette knife; the barn's paint excavated with the wooden end of the brush in long digging strokes; the tree brushed with broken short strokes; the face soft and blended. Never are two pictures alike; yet, in each, the purpose is an effective decorative expression of a personal view of nature.

Weir's new work was not well received. Even Percy Alden, whose family name Weir was using in his professional life in appreciation for early patronage, expressed shock and warned that the new paintings would not be a commercial success.[27] John Weir was equally dismayed but reiterated his faith in his brother's artistic decisions.[28] Weir, the follower of new paths, was adamant about the merit of the new pieces: "I have exhibited these things because I recognize in them a truth which I never before felt."[29]

In 1893, Weir's experiences at the World's Columbian Exposition in Chicago reinforced his tendency to simplify and abstract his subject matter. His interest in flat patterning without spatial recession and in large simplified forms was encouraged by a commission to do a mural for a ceiling in the Manufactures and Liberal Arts Building. More importantly, the Exposition seems to have intensified his interest in Japanese prints. He would have seen the collection of them being exhibited there by the Parisian art dealer Samuel Bing.

The aesthetics, if not the actual work, of the Japanese had had an impact on Weir's art since his school days in Paris. Europe had grown excited by Japanese aesthetics soon after Commodore Perry opened Japan to the Western world in 1854.[30] Eight years later, the English consul general in Japan had organized an exhibition in London of one thousand Japanese decorative objects, including colored woodblock prints. Shortly afterward, both Whistler and Manet became devotees of Japanese prints, and perspective with bird's eye views, oddly tilted foregrounds, and telescoped space, which presented foreground objects with truncated and abstract closeness, could often be found in their work. Flat patterns and blocks of color, cropped edges, and asymmetrical composition were also evident. If he did not himself know Japanese prints in the 1870s and '80s, Weir absorbed their aesthetics in that period from the works of Manet and Whistler, whom he greatly admired.

Weir would have been able to pursue his early interest in Japanese art in New York in the 1880s. There was a "craze" in New York then for Japanese decorative arts, and a number of oriental arts emporiums had opened. Shugio Hiromichi, who had arrived in New York in 1880, was a Tile Club member, like Weir, and friendly not only with him but with other celebrated artists, collectors, and society figures.[31] He owned

Fig. 14
J. Alden Weir, Feather, about 1893, ink on paper, signed at lower right: J. Alden Weir; notation on mat: "One of 70 drawings made of a feather to try to render it in a simple manner, as the Chinese do. J.A.W." (private collection).

[27] *Young, pp. 177-78.*

[28] *Young, p. 177.*

[29] *Young, p. 176.*

[30] *Two excellent books discuss the history of the opening of Japan to the West and its effect on American art: Julia Meech and Gabriel P. Weisberg, Japonisme Comes to America: The Japanese Impact on the Graphic Arts 1876-1925 (New York: Harry N. Abrams, Inc., 1990); and William Hosley, The Japan Idea: Art and Life in Victorian America (exh. cat., Wadsworth Atheneum, Hartford, 1990). For the opening of Japan and the European discovery of its aesthetics, see Hosley, p. 30.*

[31] *Hosley, p. 43.*

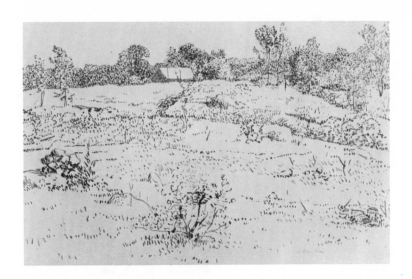

Fig. 15
J. Alden Weir, A Look Across the Fields, *about 1894, pencil, ink and brush on paper, 9⅜ x 14⅜ in., signed at lower right: J. Alden Weir (Brigham Young University, Provo, Utah).*

[32] *Young, p. 186.*

[33] *This interest was further enhanced by the exhibition at Boston's Museum of Fine Arts later that year, which Weir probably saw with Twachtman at the time of Weir's wedding there to Ella Baker. See Burke's discussion of Weir's Japanese print collection, pp. 205-08. Her notes 36 and 37 (p. 271) list invoices for Japanese prints from Bing to Weir. Susan Larkin has alerted me to the existence of another invoice from Bing dated 1889.*

[34] *I would like to thank Julia Lippert, who brought to my attention the specific types of Japanese brushstrokes used by Weir. Frits Van Briessen's The Way of the Brush-Painting Techniques of China and Japan (Rutland and Tokyo: Charles E. Tuttle, 1962) is the basic reference on this subject. Lippert's master thesis at Brigham Young University, due for completion in the fall of 1991, will focus on oriental techniques and influences in Weir's art.*

several Japanese decorative arts stores, including one on Broadway (and another in Paris) and deliberately advanced appreciation of Japanese culture. The most famous oriental art dealer of the day, Samuel Bing, who had opened his oriental decorative arts shop in Paris in the early 1880s, where his promotion of Japanese prints, as well as of high quality oriental porcelains and crafts, attracted the attention of artists, opened a second shop in New York in April 1877 that was also frequented by artists. Through dealers like these, Weir could have known Japanese art personally in New York during this period, a likelihood supported by his daughter, Dorothy Young, who remembered that Weir began collecting Japanese prints in the 1880s.[32]

Several works that Weir created just after the World's Columbian Fair reflect a strong interest in oriental art.[33] Chinese ink drawings directly inspired a series of some seventy drawings of a feather, in which he struggled with the difficulty of using a few strokes of a brush to express the feather's essential qualities (fig. 14). Japanese pen and ink drawing also inspired him in landscape subjects, where ink marks, like alphabet letters, by their very nature seem to define the surface of the paper. Weir used a selection of different Japanese ink strokes scattered over the surface.[34] *A Look Across the Fields*, c. 1894 (fig. 15), for example, adapts Japanese pen and ink techniques to Weir's Western landscape format; the result is strongly abstract. In other drawings, such as *Ella Making a Wreath*, c. 1894, Weir used differently-shaped ink marks as textures to differentiate flat blocks of the composition. In both cases this adaptation of Japanese ink drawing to the artist's personal style is comparable to the use Van

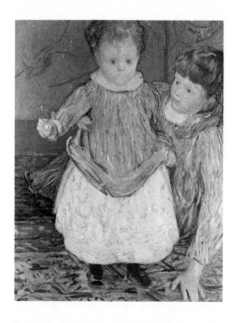

Fig. 16
J. Alden Weir, In the Days of Pinafores,
about 1893-94, oil on canvas, 34⅛ x 27⅛ in.,
signed at lower left: J. Alden Weir (private
collection).

Gogh made of the same technique. Weir may have been familiar with Van Gogh's drawings, or perhaps the two men simply saw the same possibilities in the technique.[35]

Bing, who corresponded with Weir in the mid-1890s and sold him a number of Japanese prints, almost certainly introduced him to the art of the French Post-Impressionist Nabis at this time. The Nabis, including Vuillard, Bonnard, Denis, and Serusier, gathered at Bing's Paris shop, because of their interest in Japanese art.[36] Weir's painting, *In the Days of Pinafores,* 1893/94 (fig. 16), makes a connection to the Nabis convincing. Here are the cropped figures pushed close to the surface, the odd telescoped perspective, and also the flat blocks of textured color so evocative of the Japanese and so similar to Vuillard's work. Unlike the work of the Nabis, which often tends toward prettiness, Weir's elevates his subject to the level of the universal by his sensitive portrayal of a child taking her first steps, protected and supported by an older sister. The triangle of the child's form is encompassed by the arc of the sister's arm, firmly supported by the star-shape of her foreground hand. Colored bands suggest both space and the surface of the canvas and provide buttresses for the form of the child. A graceful flight of birds near the child's head prefigure the success of the little fledgling. This combination of modern abstraction, strong patterning, and warm human content was Weir at his very best. Yet Weir would not repeat this Nabi-like style.

[35] *An excellent selection of Van Gogh's drawings are reproduced in Ronald Pickvance,* Van Gogh in Arles *(exh. cat., Metropolitan Museum of Art, with Harry N. Abrams, Inc., New York, 1984). See Pickvance's notes for each drawing.*

[36] *Agnes Humbert,* Les Nabis et Leur Epoque, 1888-1900 *(Geneva: Pierra Cailler, 1954).*

The 1890s were exceptionally fruitful for Weir. In the years between 1894 and 1897, he produced *Baby Cora, In the Dooryard, Obweebetuck,* and *The Laundry*, each a masterpiece, each distinctly different. All led decisively to the unqualified success of *The Red Bridge* and *The Factory Village*. It was in 1898, after the completion of this extraordinary string of paintings, that Weir, with Twachtman and Hassam, formed the group The Ten American Painters, and through it acquired a reputation as one of America's foremost Impressionist painters.[37]

The Ten, which continued for twenty years, consisted of ten painters who seceded from the Society of American Artists to exhibit together as a group. All of them felt that the Society had become as formal and traditional as the National Academy, from which it had split twenty years earlier. The Society's juries tended to select paintings that were inoffensive and competent rather than those which were challenging or progressive. Because of the enormous size of the exhibitions, the good work that was admitted had little chance of being noticed. The Ten no more intended to demonstrate consistency in style than the European Impressionists had. Like them, these painters simply sought to present a forum where artists whose general outlook was compatible could exhibit together. Nevertheless, it was obvious from the start that most members of The Ten conformed to the general understanding of the term "Impressionist."

Weir's paintings in the years that he exhibited with The Ten are generally excellent examples of American Impressionism. Many of his summer landscapes, such as *At the Turn of the Road*, 1910-19, or *The Fishing Party* (fig. 17), have the easy Impressionist charm of works by Metcalf or Hassam, in which a consistent use of broken brushwork to represent sunshine and shadows creates a light-filled effect. In important pieces from these years, however, the Impressionist surface is used to enrich and soften the modernism. Weir's *Building a Dam, Shetucket*, 1908, is a good example of this. Despite the Impressionist overlay, a telling "airlessness" is evident and the dominant surface pattern intrudes on the subject's reality. The rhythms of verticals and angles that bind the elements of nature to those of the manmade construction demand attention. The strong colors and textures of the natural elements contrast with the ghostly colors and flat texture of the dam area. Sunshine is not illustrated. The flat white beige of the middle area suggests "glare," the deep green suggests "shadow," but without three-dimensional form or perspective space, the concept is too abstract to seem realistic. It is evident that Weir had not eradicated his experimentation but had even enhanced it.

Upland Pasture, c. 1905 (pl. 13), demonstrates how Weir's Impressionism affected his art. Like many of his late paintings, this work reviews an early format and subtly

[37] See Ten American Painters (exh. cat., Spanierman Gallery, New York, 1990) for a study of this group.

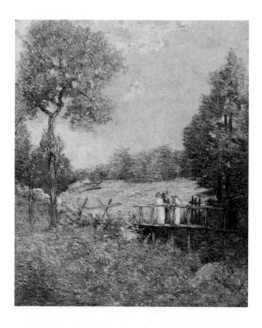

Fig. 17
J. Alden Weir, The Fishing Party, *about 1915,*
oil on canvas, 28 x 23⅛ in. (The Phillips Collec-
tion, Washington, D.C.).

changes it. *Upland Pasture* is much like the *Lengthening Shadows* of almost twenty years earlier. Both have shadows cast by unseen objects that pattern the sunshine of a hillside that rises to a high horizon. Both are all but empty of human presence. In the late painting, however, Weir has relaxed the rigidity of the earlier piece's geometry, filled it with light-saturated colors, and enlivened it with a rich variety of brushwork. The transitory presence of late summer sunshine is wedded to the enduring structure Weir saw underlying nature's surface, and the result is a mellow combination of the best characteristics of both. Paintings such as this, in which the more radical elements are balanced by the charm of Impressionist technique, were the basis of Weir's fame in his late years.

Although Weir may not have fully realized it, his approach to art had as much in common with European Post-Impressionism as it did with Impressionism. Weir painted the world subjectively, as did the Post-Impressionists. He was as interested in the two-dimensional surface of a painting as they, and as fascinated by abstract design and composition. Like them, he was absorbed in a study of how to make the shapes, colors, and textures of objects express his thoughts and feelings about them, not reproduce them.[38] Although Weir's approach demonstrated the conservative reticence of his early training and his Americanism, his art attests to the fact that he was attuned to the most advanced aesthetic theories of his day.

[38] *John Wilmerding and Wanda Corn, "The United States,"* Post-Impressionism: Cross-Currents in European and American Painting 1880-1906 *(Washington: National Gallery of Art, 1980), pp. 219-21.*

Weir was not the only American Impressionist whose work had Post-Impressionist characteristics. Twachtman's paintings, for example, were always an interpretation, not an imitation of nature, and Hassam frequently stylized his subject matter with strongly emphasized shapes and outlines. That Post-Impressionism had made an impact on these two friends and others is not surprising; the surprise would be if such intelligent artists and teachers cared nothing for the avant-garde European art movements of their own time. Although they were considered major exponents of the Impressionist style in America, theirs was a contemporary and informed Impressionism, which reflected their own American character and the art movements of their own era.

Weir did not change in the last decades of his life. He continued to experiment with new means of expression and new aesthetic ideas. He was as excited by the landmark Armory Show in New York in 1913 as he had been by Durand-Ruel's 1886 exhibition.[39] His advocacy of all sincere and good American art, no matter what its style, continued, and both the conservative and progressive factions in the American art world honored him.

Weir's art, even at the height of his recognition, was not as "taking" as that of many of his colleagues. It was, as a *Boston Transcript* writer said, work that "needs to be lived with to give out its full measure of beauty, for like all Weir's landscapes, it does not wear its heart upon its sleeve, but is essentially elusive and personal."[40] There was the key to Weir's art, unchanged since Cook's early observations in 1878. His late paintings, like his early ones, needed time to reveal their quality. Weir purposefully understated his subjects, offering no quick intimacy or easy access to viewers. As his daughter pointed out, he disliked "having everything taken in at a glance but preferred instead that things should disclose themselves to you gradually, when you were least expecting it."[41] When asked to define art, Weir said: "With an object which is a work of art, its charm cannot be exhausted by intimate association."[42] The statement applies to his own work as well.

[39] *Forbes Watson, "J. Alden Weir," New York Evening Post Saturday Magazine, Mar. 28, 1914.*

[40] *"Works of J. Alden Weir," Boston Transcript, May 4, 1920.*

[41] *Young, p. 169.*

[42] *J. Alden Weir, "What is Art?" Arts and Decoration 7 (April 1917), pp. 316-17, 324, 327.*

A Curious Aggregation
J. Alden Weir and His Circle

Susan G. Larkin

"My friends are so glad to see me and I them that it is to me like Paradise," the exuberant J. Alden Weir wrote to his parents from Paris in June 1878. The 26-year-old artist had just been reunited with the young painters with whom he had studied from 1873 until he returned to New York the previous autumn. By August, after spending the summer painting with his comrades, he was even more convinced of the importance of friendship. "I begin to think that an artist can be bred a good workman anywhere if he has some healthy men to work with who are not influenced by the old pictures except in sentiment," he declared. [1]

Throughout his life, Weir would attract friends so diverse in personality, national origin, and artistic style that one of his students would call them "a curious aggregation." [2] Beyond their personal benefits, those friendships had a wide-ranging impact on late-19th-century American art. An examination of Weir's circle, therefore, illuminates the inner workings of the professional art world at the turn of the last century. More specifically, a study of the give-and-take between Weir and certain of his friends elucidates the creative effects of their friendship on each of them.

Weir had grown up in an environment where emotional and professional bonds overlapped. His father, Robert W. Weir (1803-1889), was one of four painters commissioned to execute large-scale historical panels for the Rotunda of the United States Capitol. As drawing instructor at the United States Military Academy, the elder Weir taught James A. McNeill Whistler, Ulysses S. Grant, William Tecumseh Sherman, and Stonewall Jackson. J. Alden Weir's half-brother, John Ferguson Weir (1841-1926), was the first director of the Yale School of Fine Arts, where he taught from 1869 to 1913. In correspondence among Robert, John, and J. Alden Weir, personal news and messages of affection are interwoven with technical advice, critiques of current exhibitions, and descriptions of works in progress.

The family background provided J. Alden Weir entrée to New York's social and cultural leaders that few of his colleagues enjoyed. His links to the city's elite are reflected in the guest list for his bachelor dinner in 1883. Elliott Roosevelt, Theodore's younger brother, was one of the ushers; other guests included Loyall Farragut, son of Civil War hero Admiral David G. Farragut, and Percy Alden, a direct descendant of

[1] Letter dated June 16, 1878, quoted in Dorothy Weir Young, The Life and Letters of J. Alden Weir (New Haven: Yale University Press, 1960), p. 142. Letter from Weir to his parents, dated Aug. 29, 1878; quoted in Young, p. 144.

[2] Joseph Pearson's letter to Dorothy Weir Young, quoted in Young, p. 193.

the Puritan John Alden. The aristocracy of talent was even better represented. Sculptors Augustus Saint-Gaudens and Olin Warner were there—the first the son of a shoemaker, the second of an intinerant preacher. The painters at that star-studded gathering included not only the celebrated dandy William Merritt Chase and the society portraitist J. Carroll Beckwith, but also the then lesser-known Will H. Low, William Gedney Bunce, Wyatt Eaton, and George Maynard. Among the other guests were architects Stanford White and Charles F. McKim; publisher Charles Scribner; editor and critic Richard Watson Gilder; collector Erwin Davis; and dealers Daniel Cottier and James T. Inglis.[3]

Weir's personality, even more than his background, made him the natural focus for a circle of gifted colleagues. After Weir returned home from Paris, the Finnish artist who had shared his studio wrote warmly of *"ton enthousiasme, ton coeur genereux,"* adding that his friends often spoke of him, never failing to exclaim *"quel brave ami, quel grand coeur, quel chic garcon."*[4] Weir's closest friend in Paris was the French naturalist, Jules Bastien-Lepage (1848-1884). Even as a student, Bastien-Lepage was recognized as one of the most gifted of his generation. Van Gogh admired his honest images of peasants; British painters applied his innovations to their pictures of Cornish fisherfolk and Highland farmers. His influence on Weir, which the American freely acknowledged, has been detected in several paintings of the 1870s and '80s.[5] More important than these specific corollaries, however, was the compromise Bastien-Lepage represented between the academy and the avant-garde. While Weir was not yet ready to follow the "Impressionalists" whose 1877 exhibition left him "mad for two or three days,"[6] he was prepared for their new departures by Bastien-Lepage's lighter palette, open-air painting, and freer brushstroke.

In a pattern that was characteristic of him, Weir gave practical expression to his friendship. He bought Bastien-Lepage's *Joan of Arc* for the American collector Erwin Davis in 1879, the year it was painted. Exhibited to great acclaim at the Society of American Artists the following winter, the painting influenced many of Weir's colleagues. In 1889, Davis gave it to the Metropolitan Museum of Art.

Soon after his return from the European studios, Weir met John Twachtman (1853-1902), who quickly became his closest friend (fig. 18). Even the individualistic Twachtman needed the emotional support of colleagues. He wrote dejectedly to Weir from his hometown, Cincinnati, "I just now wish for a few days in N.Y. to be near you. Is it possible for one to do good work away from all sympathetic art influences?"[7] Twachtman clearly thought not. His friendship with Weir would have a significant impact on the work of both men and would overflow to benefit others.

[3] *Young. p. 158.*

[4] *The Finnish artist was Albert Edelfelt (1854-1905); his letter (c. 1878) is quoted in Dorothy Weir Young's draft of "Friendships"; Weir Family Papers, Dept. of Archives and Manuscripts, Harold B. Lee Library, Brigham Young University, Provo, Utah. For information on Edelfelt, see Kirk Varnedoe's Northern Light (New Haven: Yale University Press, 1988), pp. 58-63.*

[5] *Doreen Bolger Burke, J. Alden Weir: An American Impressionist (Newark: University of Delaware Press, 1893), pp. 104-08.*

[6] *JAW to his parents, quoted in Young, p. 123.*

[7] *Twachtman to Weir, Avondale, Ohio, March 5, 1882; Weir Family Papers.*

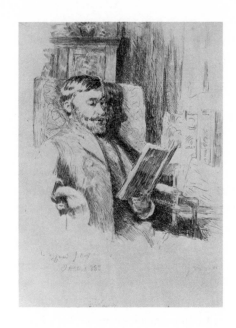

Fig. 18
J. Alden Weir, Portrait of John H.
Twachtman, *1888, etching, 6⅝ x 5¹/₁₆ in.,*
inscribed in plate lower left: To my friend J.H.T./
J.A.W. 1888 (Brigham Young University,
Provo, Utah).

[8] *For an account of that excursion, see Mahonri*
Sharp Young, "The Tile Club Revisited," Amer-
ican Art Journal 2 (Fall 1970), pp. 81-91.

[9] *JAW to Anna Dwight Baker, Aug. 21, 1882;*
Archives of American Art, J. Alden Weir Papers,
roll 125, frame 13. Anna Baker wrote to Weir on
Aug. 6, 1882, "Do you know whether Mr.
Twachtman is going to join you {in the Adiron-
dacks}? I should think it would add greatly to your
enjoyment if he did, especially as you say he always
inspires you with so much enthusiasm for art."
(AAA, frame 10.)

[10] *Young, p. 142. Young refers to the "Holly"*
House in Cos Cob as Victorian. Though it has
19th-century additions, the oldest part of the house
dates to the 17th century. Now called the Bush-
Holley House, it is the museum of the Historical
Society of the Town of Greenwich. Edward Holley
did not buy the boardinghouse until 1882, but he
may have operated it before that. Even if Weir
stayed there before the Holleys managed it, it would
have been natural for him to refer to it later by the
name under which it became well known.

The two probably met in New York City in 1878; their friendship blossomed during the Tile Club's excursion on the Erie Canal the following year.[8] In the early years of their friendship, Twachtman's moves between Ohio and France meant that they saw one another only occasionally—most memorably, on a trip to Holland in 1881 with Twachtman's bride, Martha, and Weir's older brother John. That trip reveals Weir's method of working among friends. They did not paint side by side, but set out separately after breakfast, reconvening for a convivial dinner in the evening.

From the first, Weir hoped that he and Twachtman would live near one another, possibly in the Adirondacks, where he had bought property for a summer home. When Twachtman joined him there for a painting holiday, Weir urged him to buy the adjoining land. "He is a noble fellow and the kind of a man to have as a near neighbor," Weir explained to his fiancée Anna Dwight Baker.[9] The Adirondacks house was apparently never built, however. It was in Connecticut that the friends realized their dream of living within reach of one another. In so doing, they established a Branchville-Greenwich-Cos Cob axis that became central to the history of American Impressionism.

According to his daughter, Dorothy Weir Young, Weir sometimes painted in Cos Cob, a modest waterfront section of Greenwich, during the summers between his return from Paris in 1877 and his marriage to Anna Baker in 1883.[10] Although he

travelled abroad during four of those five summers, he could easily have visited Cos Cob for short periods. Then, as now, the Holley House, where Weir stayed, is about one hour door-to-door from Grand Central Station. If Young's chronology is accurate, the Cos Cob art colony is at least ten years older than previously recognized and its origins are more closely linked to Weir.[11]

By 1883, Weir owned a house in New York City and a farm at Branchville. In addition, he often stayed at his in-laws' summer home in Windham. Twachtman, who could barely afford one home, needed a country place close to New York. Knowing how convenient the rail link was, Weir may have suggested Greenwich. Twachtman probably rented a house in Greenwich as early as 1886.[12] In the summer of 1888, he leased a place near Branchville. He and Weir enjoyed experimenting with Weir's new printing press.[13] Twachtman's etching of the farm lane conveys the euphoria of that summer of shared activity. By 1889, he was back in Greenwich. The following February, with the security of a teaching position at the Art Students League (where Weir had taught for four years), he bought the farm on Round Hill Road that would be his home and inspiration for the rest of his life.

The frequent contact in city and country had immediate benefits for both artists. Weir continued his quiet, practical services to Twachtman, selling his pictures, providing a nurse when the family was ill, and loyally nominating him year after year for membership in the National Academy of Design.[14] The two fueled one another's enthusiasm. "That was a splendid talk we had this evening and I become more convinced each time I see you," Twachtman wrote to Weir on December 16, 1891. "I want to tell you how confident I feel. Tomorrow will be a fine day and I wish for lots of canvas and paint to go to work with."[15]

The friendship extended to their families. The Twachtman children entertained the little Weirs with donkey rides through the Greenwich woods and gave them the donkeys when they outgrew them.[16] Weir guided Alden Twachtman, his godson and namesake, in the art of friendship. "Home is the starting place and love the guide to your actions," he advised the ten-year-old boy. "Great men who loved their homes and were kind and generous to their playmates in their youth, learned many truths which were of much value to them all through their lives."[17] As a student at the Yale School of Art, young Alden Twachtman enjoyed the avuncular solicitude of John Ferguson Weir. Most important, both J. Alden Weir and John Twachtman achieved their greatest mastery beginning in the late 1880s, when they first lived near one another.

Weir's training had focused on the figure, which his father and his brother considered the basis of fine art. Until about 1889, portraits and figure studies

[11] *Further evidence of a longer history for the Cos Cob art colony is a group of six paintings David Johnson (1827-1908) painted in the Greenwich area between 1878 and 1889. Among them are* October, Cos Cob *(Huntington Museum of Art) and* View Near Greenwich, Connecticut *(Hartford Steam Boiler Inspection and Insurance Company). Until now, the best-documented date for the beginning of the art colony has been 1890, the year Twachtman bought a house in Greenwich and the tonalist painter Leonard Ochtman first painted near the Mianus River. For more on the art colony, see my essays "The Cos Cob Clapboard School" in* Connecticut and American Impressionism *(Storrs: University of Connecticut, 1980); The Ochtmans of Cos Cob (Greenwich: The Bruce Museum, 1989) and On Home Ground: Elmer Livingston MacRae at the Holley House (Historical Society of the Town of Greenwich, 1990).*

[12] *The 1886 date is based on Dorothy Weir Young's typescript of a letter from Twachtman to Weir. The original is not dated and the envelope is missing; Young noted "Posted Sept. 12 1886." According to the letter, the Twachtmans, already living in Greenwich but "without a cent in the house," were going to Cos Cob to board. In a recent essay, Lisa Peters questions Young's date, speculating that the letter was written after Twachtman had settled in his own home on Round Hill Road (John Twachtman: Connecticut Landscapes {National Gallery of Art, 1989}, p. 43, note 12). This seems unlikely, since it would have been more expensive for the family to move to a boardinghouse than to stay in their own home. Peters points out that Twachtman's "handwriting in dated correspondence of the late 1880s and early 1890s is small and tight in comparison" with the large, loose cursive of the note in question. However, in letters to Josephine Holley and Elmer MacRae in 1902, Twachtman alternates between small, neat script and large, sometimes shaky scrawls. Internal evidence of the 1902 correspondence suggests that the changes reflected his health and emotional state. In the absence of further evidence, the 1886 date can neither be proved nor disproved. However, Twachtman's identification on the deed for his house as "John Henry Twachtman of said town of Greenwich" indicates that he was well established as an area resident by 1890. I am grateful to Lisa Peters*

Fig. 19
John Henry Twachtman, Landscape, 1890,
pastel, 14¾ x 18 in. (Metropolitan Museum of
Art, New York).

*and to the staff and volunteers of the Archives of the
Historical Society of the Town of Greenwich for
making the original letters available to me.*

[13] *For a discussion of Weir's prints and references to
further sources, see Burke, pp. 175-87. Mary
Welsh Baskett surveys Twachtman's etchings and
lists the bibliography in "Prints," John Henry
Twachtman (exh. cat., Cincinnati Art Museum,
1966), pp. 32-39.*

[14] *According to Childe Hassam, Weir nominated
Twachtman for 28 consecutive years. If they met in
1878, they knew one another only 24 years. It is
obvious, however, that Weir tried repeatedly to
secure for Twachtman this sign of professional
recognition. (Hassam, "Re: 'Well-Balanced
Juries,'" Archives of American Art, Papers of the
American Academy of Arts and Letters, roll
NAA1, frame 757.)*
*Theodore Robinson records in his diary, Feb.
13, 1895, that Weir sent a nurse and sold paint-
ings for Twachtman when the family fell ill with
scarlet fever. The correspondence in Young reflects
other occasions when Weir arranged the sale of
Twachtman's work.*

[15] *Quoted in Young, p. 189.*

[16] *Caroline Weir Ely, "My Father's Friends" in
Lest We Forget (privately printed, 1965), p. 50.*

[17] *Letter from J. Alden Weir to Alden Twachtman,
Jan. 3, 1892; quoted in Young, p. 177.*

[18] *Stanford White wrote to Weir on May 3, 1884
after seeing Twachtman in Paris, "I found
Twachtman hard at work—drawing—slavery—
I should think to him—but a slavery he will never
regret. . . ." (Weir Family Papers).*

constituted the majority of his work. Though rooted in the academic tradition, such paintings as the dramatic *Reverie* deservedly established Weir as a leader of the young European-trained artists. For Twachtman, on the other hand, figure drawing was "slavery."[18] Landscape was always the core of his work.

Weir began to turn toward pure landscape in the late 1880s, when he was in frequent contact with Twachtman. The divergence between his figures and his landscapes of that period is evident in two pastels. In *The Windowseat* (pl. 4), Weir used the colored chalks very differently from Twachtman, nearly covering the paper with color in an approach like Mary Cassatt's. In *Branchville Pond*, on the other hand, he left part of the paper exposed as Twachtman commonly did (fig. 19). However, the meaning of the empty paper in Weir's drawing is as carefully controlled as the meaning of the marks that signify a rowboat. Twachtman, by contrast, used a minimum of strokes to suggest, rather than define, the elements of his composition. Like a Chinese scroll painter, he allowed the viewer to fill the empty space.

In Weir's sketch of a rail fence (fig. 20), a clump of Queen Anne's lace resembles Twachtman's airy flower studies. Because it is unfinished, Weir's pastel seems close to his friend's spontaneous impressions, but Weir's pencilled outlines, ready to be filled with color, reflect a more deliberate approach. Twachtman's pastels are haiku; Weir's are sonnets.

In Weir's oil, *Early Spring at Branchville* (pl. 6), the pale hues, calligraphic trees and subordinated detail resemble such Twachtman paintings as *End of Winter.* Closer

inspection reveals their differences. Weir uses a wider range of colors than Twachtman, who tended to restrict his palette to tones of one or two colors. Weir did not push as close to abstraction as Twachtman did. Further, in his oils as in his pastels, Weir covered more of the surface than Twachtman.

Few of Twachtman's compositions include figures. The most successful of those that do, *On the Terrace* (fig. 21), is remarkably similar to Weir's *In the Dooryard* (pl. 10). In fact, Twachtman's painting may have been prompted by his friend's somewhat earlier celebration of family and home ground. Both paintings depict the artist's wife seated outdoors holding a baby and flanked by two little girls. In both, all the figures wear white. The pristine clothing functions on two levels. Formally, it allows the artists to display their virtuosity in exploring the varied tones of white—a feat they had admired in the work of Bastien-Lepage and that they repeated in their own winter landscapes. Symbolically, the white dresses emphasize the idealization of the figures.

Weir frankly states the allegorical nature of his painting by including a swag of laurel leaves and a lamb. The traditional symbol of innocence, with its realistically muddy knees, provides a natural focal point for the woman offering it a sprig of greenery and the children watching its reaction. The painting's large scale, matte finish, and classicizing devices link it to the French artist Puvis de Chavannes, who on Weir's recommendation had recently been commissioned to paint murals for the

Fig. 21
John Henry Twachtman, On the Terrace, 1890-1900, *oil on canvas, 25¼ x 30⅛ in., signed at lower left: J.H.Twachtman (National Museum of American Art, Smithsonian Institution, Gift of John Gellatly).*

Boston Public Library. The telescoping of space, flattened shapes, decorative pattern, and dramatically tilted plane reveal a sophisticated adaptation of Japanese techniques. The high horizon in Weir's painting, like the hidden horizon in Twachtman's, immerses the viewer in the painter's private world.

Twachtman also idealizes his family group, but with strategies borrowed from landscape rather than figure painting. Though the figures are pushed to the right third of the composition, their central importance is underscored by the wedge-shaped pedestal of white terrace. The family is obliquely enshrined by the sheltering gable and the Gothic-arched trellis crowned with yellow blossoms. A golden light glows within the house, as from a sanctuary. Twachtman exaggerated the scale of the white phlox in the center foreground and the pink one just behind it, making them secular counterparts of the Madonna's lily. Lacking his friend's expertise in portraiture, he left the features of his wife and children as blurred as the trees in the background. Golden highlights—on his daughters' hair, the roof of his house, the plants in his garden—serve the same idealizing function as the laurel rope in Weir's painting.

The creative benefits of the friendship between Weir and Twachtman overflowed to their students. Both men taught at the Art Students League in New York City.[19] Weir taught painting at the League, but as a studio class it was probably based on the traditional figural compositions he had mastered in the Parisian *ateliers*. Twachtman's academic drawing class (an odd assignment for him) offered little opportunity to share

[19] *Weir also taught at the Cooper Union and occasionally gave private instruction in his New York studio. According to one of his daughters, he conducted classes at Branchville during June and July for four years, beginning in 1897 (Young, p. 192).*

Fig. 22
J. Alden Weir, Portrait of Theodore Robinson,
drypoint, 7 x 5 in. (Brigham Young University,
Provo, Utah).

his personal vision. In the summers of 1892 and '93, however, younger artists painted outdoors in Cos Cob under the combined instruction of Weir and Twachtman.[20] For Weir, those summers marked the interval between Anna's death on February 8, 1892 and his marriage to her older sister Ella on October 19, 1893. "I shall have a sketching class this summer with Twachtman at Cos Cob and we hope to have enough pupils to keep the bills down to their normal size," he explained to his brother before the first session.[21] Since he did not refer to the class as a continuation of one already established by Twachtman, their collaboration may have marked the beginning of the Cos Cob summer sessions, which Twachtman continued on his own. Among those who enjoyed the combined instruction were the Post-Impressionists Ernest Lawson and Allen Tucker.

A mutual friend of Weir and Twachtman, Theodore Robinson (1852-1896; fig. 22), influenced both while profiting himself from their cross-pollination. Robinson returned to New York from Giverny, France in December 1892. As Claude Monet's protégé for the previous four years, he had been an important conduit of information about Impressionism to his American colleagues, who still tended to identify the new style by its blue and violet shadows. Weir had read Robinson's letter describing Monet's Rouen Cathedral series to his class at the Art Students League. After seeing Weir on his return to New York, Robinson noted wryly in his diary, "Miss [Ella] Baker is trying 'to see blue and purple' and is progressing."[22]

The period of Weir's greatest closeness to Robinson—from 1893 until Robinson's

[20] *Young, pp. 181 and 185.*

[21] *Archives of American Art, J. Alden Weir Papers, roll 125, frame 51.*

[22] *Robinson recorded in his diary on Dec. 15, 1892 that Weir had read his letter to his students "last spring." His notation about Miss Baker is Dec. 23, 1892. Robinson's unpublished diary for 1892-96 can be consulted at the Frick Art Reference Library, New York.*
The two basic references on Robinson are John I.H. Baur, Theodore Robinson (exh. cat., Brooklyn Museum, 1946; reprinted in Three Nineteenth-Century American Painters, Arno Press, 1969) and Sona Johnston, Theodore Robinson 1852-1896 (exh. cat., Baltimore Museum of Art, 1973). Useful but more limited in focus is The Figural Images of Theodore Robinson (exh. cat., Paine Art Center and Arboretum, 1987).

death in 1896—coincided roughly with his most marked Impressionism.[23] Scholars have justly credited Robinson with endorsing Weir's shift toward a lighter palette, but they have overlooked the two artists' impact on one another's subjects. Though their academic training gave both men a propensity for figures in the landscape, they encouraged one another to eliminate the figures, as Twachtman usually did. Robinson admired Weir's landscapes exhibited at the Century Club in spring 1894, but dismissed *The Open Book* (fig. 23) as the favorite of conservative "moss-backs."[24] He saw flaws in *Baby Cora* (pl. 1) but was enthusiastic about one of the thread-mill paintings (see pl. 14). "I liked immensely a Conn. factory town, modern, and yet curiously mediaeval in feeling," he wrote. "One feels that Dürer would have painted it that way. . . ."[25] Weir, in turn, reserved his highest praise for Robinson's pure landscapes. He "didn't care much" for the somewhat sentimental *Girl Reading*, preferring the boating pictures Robinson painted in Cos Cob in the summer of 1894.[26]

The friends' concerns extended beyond their circle. During that period of labor unrest, massive immigration, and economic depression, Weir and Robinson organized a benefit exhibition for New York's poor. They devoted as much energy to organizing and installing the show as if the proceeds were destined for their own precarious bank accounts.

It was in this atmosphere of mutual stimulation and support that Weir, Robinson, and Twachtman discovered together the liberating potential of Japanese prints.

[23] *See Burke, p. 189.*

[24] *Robinson, April 9, 1894.*

[25] *Robinson, Feb. 27, 1894. Robinson admired the "color and arrangement" of* Baby Cora, *but criticized it for "bad drawing, and queer proportions in parts."*

[26] *Robinson, Nov. 27, 1894.*

Fig. 24
Theodore Robinson, Low Tide, Riverside Yacht
Club, *1894, oil on canvas, 18 x 24 in. (Collec-*
tion of Mr. and Mrs. Raymond Horowitz).

Though Japanism had been a pervasive influence in American culture for several decades, especially through the works of Whistler, it affected the three friends most intensely when they pooled their enthusiasm. In October 1893, Twachtman returned from Boston, where he had been best man at Weir's wedding, exhilarated about the Japanese prints he had seen at the Museum of Fine Arts.[27] That marked the beginning of a first-hand involvement with Asian art. Over the succeeding months, the friends frequented auctions and exhibitions and pored over prints together at Weir's New York home, their shared responses magnifying the impact of this eye-opening aesthetic. "It is very pleasant to sit with Weir at a table and look over proofs, etchings, or *Japonaiseries* together," Robinson noted on November 30, 1893. By December 10, when Twachtman joined them for an after-dinner discussion of Japanese art, he jotted, "Tw. & W. are rabid just now on the J."

Weir brought the other two together for dinner with Shugio Hiromichi. A fellow member of the Tile Club, Shugio mounted the first significant exhibition of Japanese prints in New York and was a leader in introducing Americans to the unfamiliar art of his homeland.[28] Characteristically, Weir developed a warm friendship with the distinguished connoisseur. When Weir gave him some of his etchings, the appreciative Shugio reciprocated with a rare book on *ukiyo-e* prints.[29]

Weir was also friendly with another Japanese dealer, Hayashi Tadamasa, an entrepreneur based in Paris. According to Dorothy Weir Young, Hayashi sent her father "paper made from the inner bark of the mulberry, long-grained and delicate, as

[27] Robinson, Oct. 31, 1893. For background on American Japanism, see William Hosley, The Japan Idea: Art and Life in Victorian America (exh. cat., Hartford: Wadsworth Atheneum, 1990) and Julia Meech and Gabriel P. Weisberg, Japonisme Comes to America: The Japanese Impact on the Graphic Arts 1876-1925 (New York: Harry N. Abrams, Inc., 1990).

[28] Robinson, April 8, 1893 and Julia Meech-Pekarik, "Early Collectors of Japanese Prints and The Metropolitan Museum of Art," Metropolitan Museum Journal 17 (1984), p. 107.

[29] Archives of American Art, roll 70, frames 230 and 235-6.

[30] *Young, p. 187. For more on Hayashi, see*
Meech-Pekarik, pp. 96-99.

[31] *See the thorough analysis of Weir's Japanism in*
Burke, pp. 202-16. In a recent essay, the same
author argues that Japanism endorsed the American
artists' "enduring commitment to draftsmanship."
("American Artists and the Japanese Print:
J. Alden Weir, Theodore Robinson, and John H.
Twachtman," American Art around 1900, edited
by Doreen Bolger and Nicolai Cikovsky, Jr.
(Hanover and London: University Press of New
England, 1990), pp. 15-27.) She supports this
thesis convincingly in the case of Weir and Robinson,
less so for Twachtman. Unlike the other two artists,
Twachtman had not "especially valued draftsman-
ship." Twachtman seems closest to Japanese prints
in a concern for pattern and a tendency toward
abstraction. However, he had borrowed those same
qualities from Whistler before he is known to have
become personally interested in ukiyo-e *prints. For*
at least one contemporary critic, Twachtman's
works suggested not Japanese prints but Chinese
paintings; this area of possible influence deserves
investigation.

well as brushes and inks. One bar of ink proved to be an antique so beautifully carved that Julian could never make up his mind to use it but would every now and then take it carefully out of its box, unfold the piece of silk in which it was wrapped, and turn it over in his hands, enjoying it as a work of art in itself."[30]

Although Weir was not wealthy, he was far better able to indulge his taste for Japanism than Twachtman or Robinson. His collection of Asian artifacts, his friendship with Shugio and Hayashi, and his infectious enthusiasm opened the unfamiliar world of Japanese art not only to himself but also to his intimates. The results are evident in their work. It is important to recognize, however, that strategies that seem to be Japan-inspired may actually have been borrowed from other Western artists (who may or may not, in turn, have derived them from Japanese art). Weir's *The Red Bridge* (pl. 7), for example, may owe as much to Monet's and Caillebotte's dramatic views of *Le Pont de l'Europe* as to prints by Hiroshige and Kuniyoshi.

Twachtman assimilated Asian aesthetics so thoroughly that it is virtually impossible to isolate examples of its influence. The more limited impact on Weir and Robinson is easier to pinpoint.[31] Some paintings suggest that the friends were inspired by one another's collections of Japanese woodcuts. Robinson favored figural images, while landscapes predominated in Weir's much larger collection. In Robinson's *Low Tide, Riverside Yacht Club* (fig. 24), the central mast nearly bisects the canvas much as the tree does in a Hiroshige print Weir owned. Robinson may have borrowed the bold zigzag of shore and bridge from that print for the dock in another painting, *Anchorage, Cos Cob*. Robinson's *Boats at a Landing* (fig. 25) exhibits the distorted

Fig. 26
Olin Levi Warner, J. Alden Weir, 1880,
bronze, height 22½ in., inscribed on reverse: Alden
Weir (Metropolitan Museum of Art, Gift of The
National Sculpture Society, 1898).

space, high viewpoint, and flattened forms characteristic of Japanese landscape prints. On the other hand, the lack of modelling and emphasis on surface pattern in Weir's *In the Days of Pinafores* (fig. 15) seem closely linked to the woodcuts of Robinson's favorite Japanese printmaker, Isoda Koryusai. Without the advantage of examining one another's collections and exchanging their insights, neither Weir nor Robinson might fully have exploited the potential of Japanism.

Robinson treasured Weir's friendship. Even when Weir was "disgruntled," Robinson reflected that "I have few friends whose society is as profitable as his."[32] For the quiet bachelor, Sunday dinners with the Weirs provided a precious family warmth. "Weir's hospitality is that of a gentleman of the old school," he wrote after a visit to Branchville. "Sunday, as is his wont, he read the church service—the grown-ups listening and the babies crawling over him the while."[33] Weir tried to play matchmaker for Robinson and—knowing how home grounds inspired him and Twachtman—urged him to get a place of his own and "grow up with it."[34] But Robinson died at the age of 44 of the severe asthma that had plagued him for much of his life. After his death, Weir and several of Robinson's other friends attempted to place his *Port Ben, Delaware and Hudson Canal* in the Metropolitan Museum of Art, thus securing his reputation for posterity. When the museum's trustees declined the gift, the indignant Weir accused them of bias against American paintings. "A foreign artist has a great vogue over here," he told a *New York Times* reporter, "and the

[32] *Robinson, April 11, 1895.*

[33] *Robinson, June 11, 1894.*

[34] *Robinson, April 11, 1895.*

[35] *Quoted in Young, p. 234. After the death of*
Twachtman's daughter Elsie in 1895, Weir wrote
to the director of the Pennsylvania Academy urging
him to purchase one of Twachtman's paintings
(Young, p. 179). As in the case of the proposed
Robinson gift to the Metropolitan, Weir's generous
effort was unsuccessful.

[36] *Elizabeth Broun,* Albert Pinkham Ryder *(exh.*
cat., National Museum of American Art, 1990),
p. 21. The other indispensable study of Ryder is
William Innes Homer and Lloyd Goodrich, Albert
Pinkham Ryder: Painter of Dreams *(New York:*
Harry N. Abrams, Inc., 1989).

museum seems willing to accept any third or fourth rate painting so long as it comes from a European painter."[35] Robinson's picture went instead to the Pennsylvania Academy of the Fine Arts.

While Robinson and Twachtman worked in a style closely related to Weir's, another of his closest friends, Albert Pinkham Ryder (1847-1917), could hardly have been more different in artistic style, personality, or background. Nonetheless, the two were friends for nearly a half-century, beginning about 1870, when both enrolled at the school of the National Academy of Design. From that time, Ryder scholar Elizabeth Broun observes, Weir was "the one who more than any other sustained [Ryder]. Weir's generous, gentle nature brought out Ryder's best qualities, which remained hidden before a more judgmental or impatient person."[36] In 1880, Weir, Ryder, and their close mutual friend, sculptor Olin Warner (1844-1896), took studios in the new Benedick Building at 80 Washington Square South. The friends posed for one another, providing valuable practice without the expense of models' fees or the pressure of commissions. The three shared deep religious faith, which Weir expressed by portraying Ryder as *The Good Samaritan*. A compelling element in an otherwise unconvincing work, the head of the Samaritan conveys the sweetness and unworldliness that Ryder's friends loved in him.

Warner's bust of Weir (fig. 26) won the sculptor his first widespread public recognition at the Paris Salon of 1881 and remains his best-known work. Warner made his friend's dashing good looks an expression of inner nobility. In its combina-

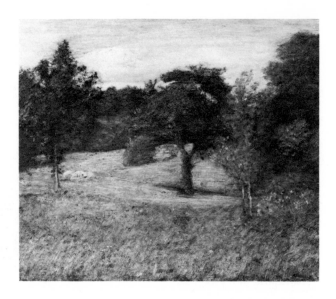

tion of realistic portraiture and heroicizing classicism, the bust is a landmark of 19th-century American sculpture.[37]

When Warner was elected an associate of the National Academy of Design, Weir painted the required portrait (fig. 27). To Warner's colleagues, the bas-relief in the background evoked his own work; to other contemporaries, who saw it as a classical or Renaissance fragment, it linked Warner to the great sculptors of the past. Though Weir portrayed Warner as a mature professional, he also captured the unaffected simplicity of the farm boy who returned home each year to help his father with the haying. Years later, Weir painted Ryder's Academy portrait (fig. 28). The subject's rosy cheeks, tousled hair, and dreamy gaze belie the trappings of a dignified Academician. Ryder valued Weir's opinion. After Weir moved out of the Benedick, Ryder scribbled him a note, "I have just painted the loveliest work of my life. I am crazy for you to see it."[38] Their work is so different, however, that their mutual criticisms cannot have had the impact of Weir's, Robinson's, and Twachtman's. Instead, Weir offered Ryder a protective, brotherly affection that became increasingly essential as the latter grew oblivious to conventional hygiene and nutrition. During one of Ryder's hospital stays, Weir arranged to have his squalid apartment cleaned. He "took one look at Ryder's bed and ordered it burnt," the younger artist Kenneth Hayes Miller later recalled.[39] When Ryder was short of funds, Weir quietly sold a picture Ryder had given him and surprised him with the $1000 proceeds. He cautioned Ryder to

[37] *For more on Warner, see Wayne Craven, Sculpture in America (Newark: University of Delaware Press, 1984), pp. 406-09; selected bibliography, p. 749.*

[38] *Undated note; Archives of American Art, J. Alden Weir Papers, roll 125, frame 69.*

[39] *Miller made this remark to Lloyd Goodrich on June 26, 1947; quoted in Homer and Goodrich, p. 232.*

budget the windfall at $25 a month. "This will give him three years as he said he spent but fifteen cents a day for food," Weir told their mutual friend, Col. C.E.S. Wood. "I trust it will keep some of the worry away and he may get back to painting."[40]

Ryder was one of Weir's few intimates who did not relish country pleasures. Instead, he preferred solitary nocturnal rambles from Greenwich Village to Hackensack, Hoboken, or the Bronx. ("Incorrigible," Weir huffed on learning of one such jaunt. "He will certainly some day join the tramp brigade."[41]) Occasionally, however, Ryder visited the Weirs in Branchville. His host even had an outside door cut into the room he occupied there so the timid artist could come and go unobserved.[42] Ryder painted at least two works at Weir Farm. The unlocated *Hunter and Dog* depicts Weir mounted on horseback ready to canter off with his pointer. In *Weir's Orchard* (fig.29), the grass under the trees glows in the late-afternoon sun. Though more literally descriptive than most of Ryder's work, this image of joyful harmony reveals his approach to nature. He invested trees and brooks with mystical qualities—he once described a fruit tree at Branchville as "eloquent," "like a spirit," with "fairy blossoms"[43]—and used the natural world to express his thoughts and emotions. Unlike Weir, who painted his landscapes in the open air, Ryder worked slowly in his cluttered studio to distill memory, music, mythology, literature, and dreams into powerful expressions of his inner landscape.

No one in America was painting quite like Ryder, but Weir was among those who recognized his genius. Because Weir was a highly influential leader of the American art world at the turn of the century, his appreciation for Ryder helped to shape the eccentric painter's reputation.[44] Ryder was elected to the National Academy of Design in 1906, though he had stopped participating in its exhibitions eighteen years earlier.[45] Soon after this belated recognition by the Academy, the mythologizing criticism began that placed Ryder in the vanguard of modernism. Weir had been an active (sometimes critical) member of the Academy since 1886; he served on its Council from 1907-14 and was its President from 1915-17. Though his respect for Ryder was by no means the decisive factor in establishing his friend's reputation, it clearly helped secure recognition for an artist whose works fit no preconceived category.

Charles Erskine Scott Wood (1852-1944) shared Weir's devotion to Ryder. Wood met Weir when he was a cadet at West Point. Their friendship endured even after Wood settled in Portland, Oregon, where he practiced law, wrote poetry, and cultivated patronage of his favorite Eastern artists. Wood's tastes were conservative. He pressured Weir to resume his bravura still lifes in the late 1890s, long after the

[40] *Weir to Wood, Dec. 25, 1910, quoted in Young, p. 228.*

[41] *Weir to Wood, Aug. 15, 1903; quoted in Young, p. 219.*

[42] *Homer, pp. 32-33.*

[43] *Quoted in Young, pp. 188-89.*

[44] *Elizabeth Broun writes (p. 179), "Perhaps Ryder would be . . . little known today . . . were it not for the fact that his closest lifetime friends, {Charles} de Kay and Weir, were the New York Times art critic and the president of the National Academy, while his later champions, {Arthur B.} Davies and {Kenneth Hayes} Miller, became proselytizers for modernism and tradition. Each of the four undertook in his way to prescribe the future of American art, including Ryder as a standard-bearer." Broun does not elaborate on Weir's influence, but offers an illuminating analysis of the role of personal mythology in Ryder's reputation, especially pp. 2-6 and 134-52.*

[45] *Broun, p. 80.*

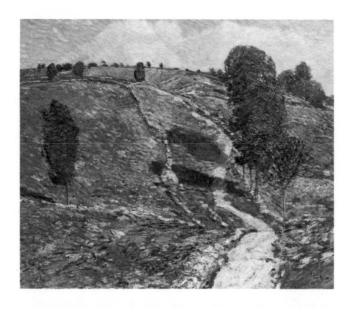

Fig. 30
Childe Hassam, Road to the Land of Nod,
1910, oil on canvas, 23¼ x 29⅛ in., signed at
lower right: Childe Hassam 1910 (Wadsworth
Atheneum, Hartford, Ella Gallup Sumner and
Mary Catlin Sumner Collection).

painter had adopted a lighter palette and open-air subjects. Having sold *The Open Book* to a Portland collector, he urged Weir to return to allegorical subjects that conveyed the "same delight the old Greeks must have felt in their tales of dryads, nymphs and the whole attendant train of the god Pan."[46] As late as 1913, Wood asked Weir to make "two poetic idyllic illustrations" for a limited edition of his poems celebrating free love. Weir demurred, protesting that "I draw the line at free love. Old Muley [Childe Hassam] I think has a strong belief in that faith, but he is losing his teeth and why not the rest."[47]

Apart from his well-intentioned meddling, Wood was a loyal patron of Weir, Ryder, Warner, and Hassam. Weir's portrait of him captures both the vigor of the former soldier and the sensitivity of the poet. The delighted subject compared it with his superficially flattering likeness by Alphonse Jongers. "It makes me *sick*," Wood declared of the Jongers portrait. "I'd rather *be* the man you painted a thousand times more than the other."[48]

Wood shared Weir's love of outdoor activity, as did Childe Hassam (1859-1935). Hassam came to Branchville to fish and hunt with Weir and their mutual friend, the Western painter Frederic Remington, who on Weir's recommendation had settled in nearby Ridgefield. Although Hassam's visits to Branchville were primarily social, he produced a small body of oils and pastels there.[49] He portrayed one of Weir's daughters in the dappled sunlight of the front porch. *Road to the Land of Nod* (fig. 30)

[46] *Wood to Weir, August 1903; quoted in Young,* p. 221.

[47] *Letters between Weir and Wood, winter 1913, quoted in Young, p. 245.*

[48] *Letters from Wood to Weir, quoted in Young,* p. 218 and 214-15.

[49] *See Kathleen Burnside's valuable essay,* Childe Hassam in Connecticut *(exh. cat., Florence Griswold Museum and Historical Society of the Town of Greenwich, 1987). I am grateful to Ms. Burnside for information on Hassam's* Portrait Out of Doors of Julian Weir's Daughter *(1909), now in the Crocker Art Museum, Sacramento, California.*

shows old stone walls and a tree-lined lane snaking up a hillside to a high horizon banked with billowing clouds. The stone walls, rail fences, and red barns at Weir's farm must have endeared the place to Hassam, who cherished the simple architecture of his New England heritage.

The Hassams, Weirs, and Twachtmans saw one another frequently in city and country. "I remember a Thanksgiving dinner in the [Weirs'] 12th Street house," Hassam recalled, "with Weir and a turkey at one end of the old oak table . . . and . . . Twachtman and another turkey at the other end."[50] An outgrowth of their friendship was the exhibition society called The Ten. It is unclear which of the three originated the idea, but Hassam, Weir, and Twachtman organized the group in the winter of 1897-98.[51] Friendship rather than stylistic consistency determined its membership. Although The Ten is seen today as an informal academy of American Impressionism, it was not conceived as such. Two members were never Impressionists; others adopted that style only after they joined the group. The role of friendship in determining membership would have been even more marked had Alfred Q. Collins (1855-1903) accepted the invitation to join. A close friend of Weir, Twachtman, and Hassam, Collins was a portrait painter.

Of those who did join The Ten, Willard Metcalf, Thomas Dewing, Edward Simmons, and Robert Reid were, like the original three, habitués of The Players Club on Gramercy Park. The Boston contingent, Edmund Tarbell, Frank Benson, and Joseph DeCamp, were well known to them as fellow exhibitors, jury members, and award-winners at the Society of American Artists, the National Academy of Design, the Pennsylvania Academy of the Fine Arts, and the Boston Art Club. Moreover, DeCamp shared Twachtman's Cincinnati hometown and Munich training. After Twachtman's death in 1902, his place was taken by William Merritt Chase, who had been an usher at Weir's 1883 wedding. Weir participated in every exhibition from the first in 1898 to the last in 1919, usually showing more works than any other member. Though The Ten had inevitably become old-fashioned by its final exhibition, it was credited by contemporary critics with improving both public taste and the quality of American painting.[52]

The Danish-born Emil Carlsen (1853-1932) was not a member of The Ten but, like Weir and Twachtman, he found many of his subjects and eventually made his home in Connecticut.[53] Carlsen, who was best known, then and now, for his still lifes, once owned a study of roses by Weir. Weir's thickly painted still lifes, influenced by Manet, are usually dark, complex arrangements of flowers and precious objects. Carlsen's blonder, more cerebral ones reveal his debt to the earlier master, Chardin,

[50] Childe Hassam, "Reminiscences of Weir" in J.B. Millet, ed., Julian Alden Weir: An Appreciation of His Life and Works (New York: The Century Association, 1921), p. 69.

[51] For a thorough study of that group, see Ten American Painters (exh. cat., Spanierman Gallery, 1990).

[52] William H. Gerdts, "The Ten: A Critical Chronology" in Ten American Painters, p. 75.

[53] The Carlsens often visited the Weirs in Windham in the early 1900s; there, Carlsen painted the simple parish church and the cottage where he and his family stayed.

Fig. 31
Emil Carlsen, Weir's Tree, *about 1905, oil on canvas, 30 x 35 in., signed at lower right: Emil Carlsen (Collection of Diana and Richard Beattie, New York).*

in their humble objects, simple compositions, and emotional restraint. Carlsen's landscapes, to which he devoted increasing attention after the turn of the century, are more closely related to Weir's. During the summer he spent in Branchville while his own house in Falls Village was being built, Carlsen painted *Weir's Tree* (fig. 31). The sunny palette resembles that in Weir's most Impressionistic works. An even more fundamental link to Weir is the sense of place. The title announces this specificity; Carlsen portrays this tree and none other. The towering, shaggy-barked sycamore, its top broken by a long-ago storm, its ungainly limbs stretching toward the pond, is as individual as a favorite old dog.

The links between Weir's and Carlsen's 20th-century landscapes may have a technical basis. Carlsen's dealer, F. Newlin Price, attested that "no one [was] a better technician in the preparation of canvas than he." According to Price, Carlsen prepared six canvases for Weir. On his next visit to Weir's home, Carlsen discovered that his friend had hung the canvases without adding a brushstroke of his own. "'Old Carlsen, they were too beautiful,'" Weir explained.[54] Since commercially prepared canvases were readily available, Weir's admiration for Carlsen's suggests they lent a particular quality to his paintings. Specialized investigation, including a study of both artists' unfinished pictures, is necessary to determine the effect of Carlsen's preparations on both Weir's paintings and his own.

[54] F. Newlin Price, "Emil Carlsen—Painter, Teacher," *originally published in* International Studio *LXXV (July 1922), reprinted in* The Art of Emil Carlsen 1852-1932, *exh. cat. (San Francisco: Wortsman Rowe Galleries, 1975), p. 53. Caroline Weir Ely recalled that Carlsen "had a special way of under painting canvasses, and generously prepared many for Father." (Caroline Weir Ely, "My Father's Friends" from* Lest We Forget *{privately printed, 1965}. p. 54). Carlsen almost certainly did not do Weir's underpainting—that term refers to the blocking-in of the composition, an integral part of the creative process. Rather, he must have applied the ground, or layer of paint over the fresh canvas. The ground establishes the overall tone; a gray ground was favored by the Tonalists, a pale one by Monet. It also determines the basic texture of the painting: thickly applied, it provides a smooth surface; more thinly brushed, it preserves the weave of the canvas. For more information, see Waldemar Januszczak, ed.,* Techniques of the World's Great Painters *(Oxford: Phaidon Press, 1980), pp. 102-3 and elsewhere.*

Throughout his life, Weir attracted friends of all personalities and ages.[55] Younger painters who replaced him and his circle in the artistic vanguard enlisted Weir to lend credibility to their fledgling organizations. When Elmer MacRae (1875-1953) decided in 1910 to organize the Pastellists, his first step was to seek Weir's support.[56] The following year, when a group of young artists resolved to mount the landmark exhibition later called the Armory Show, they elected Weir president of the sponsoring organization. Though he promptly resigned, their choosing him as leader reflects both his professional status and his sympathy for younger artists. As the sculptor John Flanagan put it, "Weir is the kind of a man one would like to have had for a father."[57]

Weir's circle was indeed "a curious aggregation," but he cherished the unique attributes of each friend. He could dream aloud with Twachtman, laugh loudly with Hassam, speak gently to Ryder, and angrily to defend Robinson. A study of his friendships is a reminder that personal qualities are as powerful as technical advances and stylistic innovations in shaping the human history of art.

[55] *Besides those mentioned in this essay, other friends who, according to Dorothy Weir Young, visited Weir at Branchville included J. Appleton Brown, Edmund Tarbell, William Gedney Bunce, Frank Millet, John Singer Sargent and Wilfred de Glehn. Robert Blum wrote to Anna Weir on July 23, 1888 after a visit to Branchville, "I have recovered from the fatigues of Hay Raking and my blisters have subsided." (AAA roll 125, frame 40.)*

[56] *See On Home Ground: Elmer Livingston MacRae at the Holley House, pp. 35-37.*

[57] *Quoted by Mahonri M. Young, "J. Alden Weir: An Appreciation" in J. Alden Weir 1852-1919, exh. cat., American Academy of Arts and Letters, 1952.*

Plate 1
J. Alden Weir
Baby Cora, 1894
oil on canvas, 70 x 40 in.
inscribed at upper right: BABY CORA; signed and dated left of center: J. Alden Weir—1894;
dated on the dog's collar: 1894
(private collection)

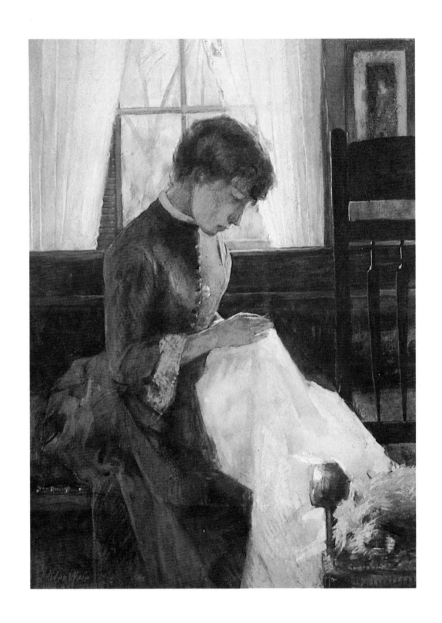

Plate 2
J. Alden Weir
Anna Sewing, 1885
pencil, watercolor, and gouache on paper, 12 x 9 in. (sight), signed and dated at lower left: J. Alden Weir/ 1885
(private collection)

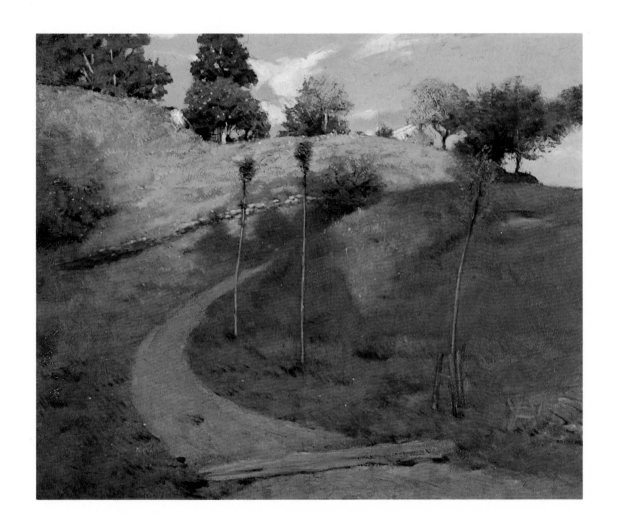

Plate 3
J. Alden Weir
Lengthening Shadows, 1887
oil on canvas, 20¾ x 25 in., signed at lower left: J. Alden Weir—1887
(Dr. and Mrs. Demosthenes Dasco)

Plate 4
J. Alden Weir
The Windowseat, 1889
pastel and pencil on paper, 13¼ x 17½ in. (sight)
signed and dated at lower right: J. Alden Weir/ 1889; and at upper right: J. Alden W—
(private collection)

Plate 5
J. Alden Weir
Obweebetuck, mid-1890s
oil on canvas, 19½ x 23¼ in.
(private collection)

Plate 6
J. Alden Weir
Early Spring at Branchville, 1888-90
oil on canvas, 20¼ x 25¼ in., signed at lower left: J. Alden Weir
(private collection)

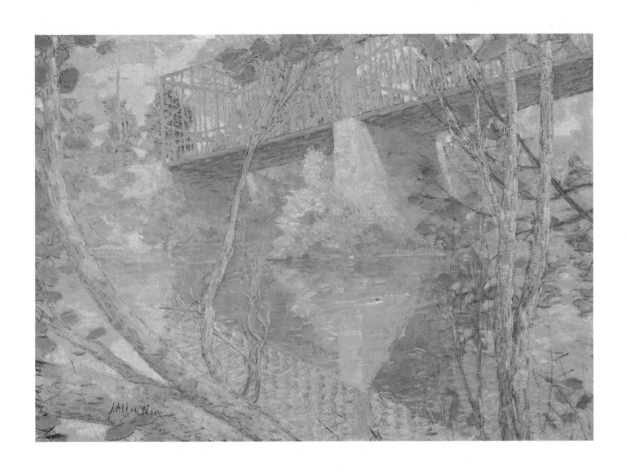

Plate 7
J. Alden Weir
The Red Bridge, about 1895
oil on canvas, 24¼ x 33¼ in., signed at lower left: J. Alden Weir
(The Metropolitan Museum of Art, Gift of Mrs. John A. Rutherfurd, 1914)

Plate 8
J. Alden Weir
Silver Chalice, Ceramic Jar, and Vase, about 1882-84
oil on wood, 19 x 11⅜ in.
(private collection)

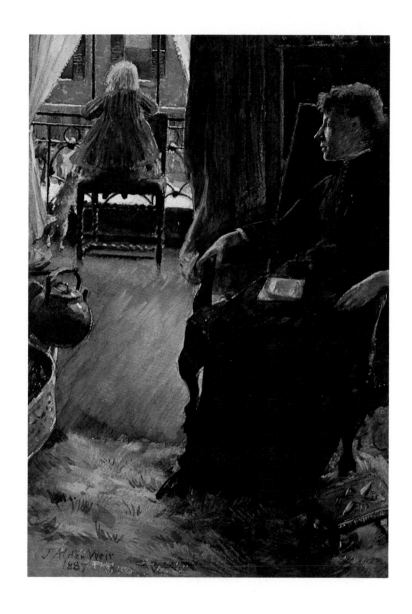

Plate 9
J. Alden Weir
Anna and Caro in the Twelfth Street House, 1887
pencil, watercolor, and gouache on paper, 17½ x 13¼ in. (sight), signed and dated at lower left: J. Alden Weir/1887
(private collection)

Plate 10
J. Alden Weir
In the Dooryard, probably 1894
oil on canvas, 80⅛ x 47⅛ in.
(private collection)

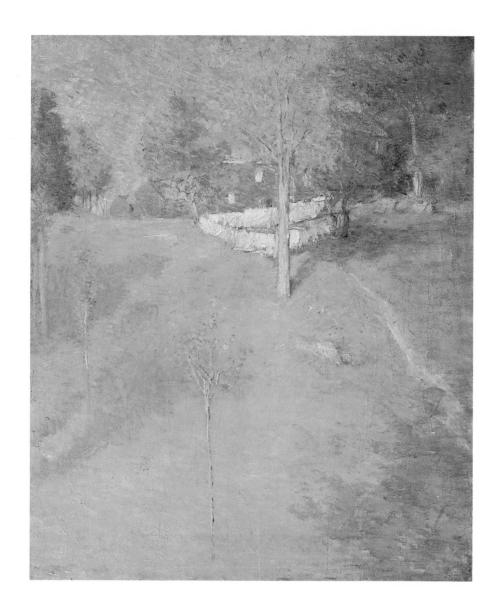

Plate 11
J. Alden Weir
The Laundry, Branchville, about 1894
oil on canvas, 30⅛ x 25¼ in., signed at lower right: J. Alden Weir
(Weir Farm Heritage Trust, Gift of Anna Ely Smith and Gregory Smith)

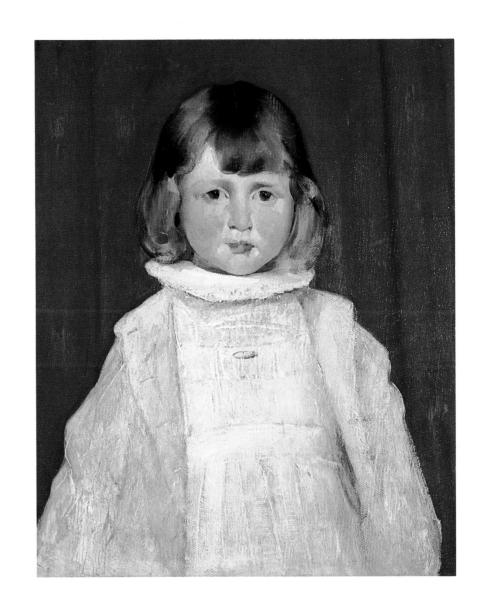

Plate 12
J. Alden Weir
Caro, 1887
oil on canvas, 24¼ x 20⅛ in., signed at upper left: J. Alden Weir—87
(private collection)

Plate 13
J. Alden Weir
Upland Pasture, about 1905
oil on canvas, 39⅞ x 50¼ in., signed at lower left: J. Alden Weir/Branchville
(National Museum of American Art, Smithsonian Institution, Gift of William T. Evans, 1909)

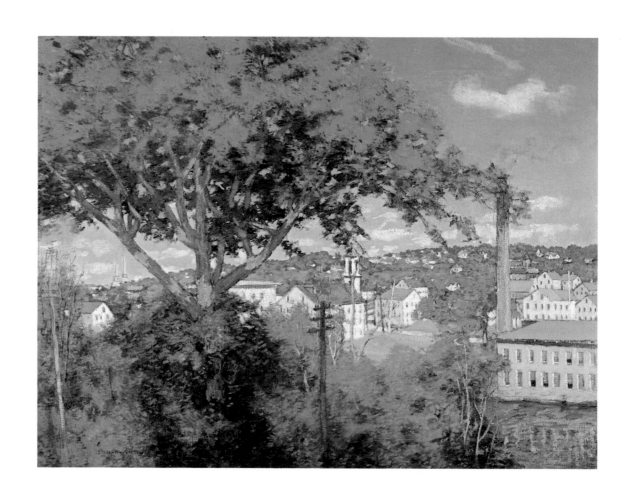

Plate 14
J. Alden Weir
The Factory Village, 1897
oil on canvas, 29 x 38 in., signed and dated at lower left: J. Alden Weir 1897
(jointly owned by The Metropolitan Museum of Art and private collectors)

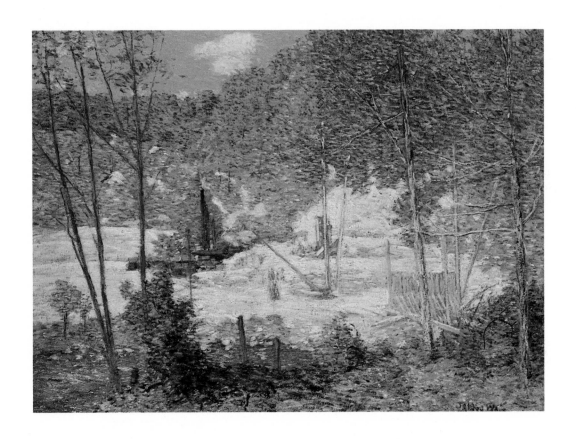

Plate 15
J. Alden Weir
Building a Dam, Shetucket, 1908
oil on canvas, 31¼ x 40¼ in., signed at lower right: J. Alden Weir
(Cleveland Museum of Art, Purchase from the J.H. Wade Fund, 1921)

Plate 16
J. Alden Weir
Midday, 1891
oil on canvas, 34 x 24½ in., signed and dated at lower right: J. Alden Weir '91
(private collection)

1852 Born August 30, at West Point, New York, son of Robert W. Weir, drawing professor at the United States Military Academy, and his second wife, Susan Martha Bayard Weir

1866 First drawings and paintings dated to this year

1868-
1869 Works in Tenth St. Studio Building, New York, in half-brother John Ferguson Weir's studio while latter is in Europe

1869-
1872 Studies at National Academy of Design, New York. Principal instructor: Lemuel Wilmarth

1873 Studies at the Ecole des Beaux-Arts, Paris, with Jean-Léon Gérôme, with financial support from godmother, Mrs. Bradford Alden

1874 Summer trip to Brittany

1875 Portrait accepted at the Paris Salon; exhibits at the National Academy of Design, New York; wins second-class medal (highest award) in Gérôme's studio

1876 Two works accepted at Paris Salon; summer trip to Spain

1877 Ranks 16th in competition at Ecole des Beaux-Arts; sees third group exhibition of the Impressionists; visits Whistler in London; returns to New York in October

1878 Exhibits with and joins new Society of American Artists; summers in Europe (returning often until 1882); joins Tile Club; begins teaching at Cooper Union and Art Students League

1880 Begins exhibiting at American Watercolor Society; elected vice president of the Society of American Artists; visits Bastien-Lepage in France and buys his *Joan of Arc* for Erwin Davis, New York collector

1881 In Paris and then in Holland with brother John and with John Henry Twachtman; visits Whistler again in London

1882 Acquires Branchville, Connecticut farm; elected president of Society of American Artists; wins silver medal at Paris Salon

1883 Marries Anna Dwight Baker

1884 First solo exhibition, Doll & Richards, Boston; elected to American Water Color Society; birth of first child, Caroline

1885 Elected an associate member of the National Academy of Design

1886 Elected to full membership in the National Academy of Design; buys home at 11 E. 12th St., New York, where he lives and works for the next twenty-two years

1887 Begins to etch; birth of son Julian Alden Weir, Jr.; Twachtman rents a house near Weir's Branchville farm and they work together, especially on pastels

1888 Exhibits with Society of Painters in Pastel and with New York Etching Club; painting landscapes frequently now

1889 Exhibits with Twachtman at Fifth Avenue Art Galleries; baby son dies; father dies; spends three weeks on the Isle of Man on a series of etchings; wins silver medal for painting and a bronze for watercolors and drawings at the Universal Exposition, Paris, which he visits

1890 Birth of second daughter, Dorothy

1891 Solo exhibition at Blakeslee Galleries, New York; critics calling him an Impressionist now

1892 Birth of third daughter, Cora; wife Anna dies a few days later on February 8; paints a mural for the Manufactures and Liberal Arts Building at the World's Columbian Exhibition, Chicago

1893 Visits the World's Columbian Exhibition; exhibits with Twachtman, Paul Albert Besnard, and Claude Monet at the American Art Association in May; marries Ella Baker, his first wife's sister, October 29

1896 Wins first prize at the Boston Art Club; uses money to build a pond at Weir Farm

1897- Teaches summer classes at Branchville; resigns
1901 from the Society of American Artists

1898 Becomes a founding member of The Ten American Painters; contributes to the group's exhibitions until it disbands in 1919

1899 Gives up teaching to devote himself to painting; takes studio at Tenth St. Studio Building

1900 Exhibits three paintings at Universal Exposition, Paris, and wins a bronze medal

1901 Exhibits at Pan-American Exposition, Buffalo; goes to Europe with his family, visiting Whistler and John Singer Sargent in London and his old teacher Gérôme in Paris

1908 Moves residence to an apartment at 471 Park Ave.

1911 Elected president of the new Association of American Painters and Sculptors but resigns when the group announces its opposition to the National Academy of Design

1911- Retrospective exhibition of his work travels from
1912 St. Botolph Club, Boston, to Century Association, New York, to the Carnegie Institute in Pittsburgh, the Buffalo Fine Arts Academy, and the Cincinnati Art Museum; develops heart disease

1912 Goes to England and Scotland in the summer

1913 Visits Nassau; in England again, at Itchen River, Winchester; exhibits at the Armory Show; honored by a dinner at the Salmagundi Club of New York

1915 Elected president of the National Academy of Design; elected to American Academy of Arts and Letters; visits Nassau again; jury member and exhibitor at Panama-Pacific International Exposition, San Francisco, where he wins a medal

1919 Founding member of new exhibition organization, American Painters, Sculptors, and Gravers; dies in New York December 8

Archives of American Art, Smithsonian Institution, J. Alden Weir Papers, Microfilm Roll 125 and others.

Bolger, Doreen. "American Artists and The Japanese Print: J. Alden Weir, Theodore Robinson, and John H. Twachtman," *American Art Around 1900: Lectures in Memory of David Fraad."* Washington: National Gallery of Art, 1990.

Burke, Doreen Bolger. *J. Alden Weir: An American Impressionist.* Newark: University of Delaware Press, 1983.

Clark, Eliot. "J. Alden Weir," *Art in America* 8 (August 1920): 232-42.

Coffin, William A. *Memorial Exhibition of the Works of Julian Alden Weir.* Exh. cat., Metropolitan Museum of Art, New York, 1924.

Cox, Kenyon. "The Art of J. Alden Weir," *Burlington Magazine* 15 (May 1909): 131-32.

Ely, Catherine Beach. "J. Alden Weir," *Art in America* 12 (April 1924): 112-21.

Flint, Janet A. *J. Alden Weir: American Impressionist 1852-1919.* Exh. cat., National Collection of Fine Arts (now The National Museum of American Art), Washington, 1972.

Gerdts, William H. *American Impressionism.* New York: Abbeville Press, 1984.

Julian Alden Weir: An Appreciation of His Life and Works. J. B. Millet, ed. New York: The Century Association, 1921; reprint, The Phillips Publications, No. 1, New York, 1922.

McSpadden, Joseph Walker. "Julian Alden Weir: The Painter of the Personal Equation," *Famous Painters of America.* New York: Dodd, Mead, and Company, 1916, pp. 377-93.

Paintings by J. Alden Weir. Essay by Mahonri Sharp Young. Exh. cat., The Phillips Collection, Washington, 1972.

Phillips, Duncan. "J. Alden Weir," *American Magazine of Art* 8 (April 1917): 213-20.

——————. "J. Alden Weir," *Art Bulletin* 2 (June 1920): 189-212.

Ten American Painters. Exh. cat., Spanierman Gallery, New York, 1990.

Weir Family Papers. Mss. 511, Department of Archives and Manuscripts, Harold B. Lee Library, Brigham Young University, Provo, Utah.

Young, Dorothy Weir. *The Life and Letters of J. Alden Weir.* New Haven: Yale University Press, 1960.

Young, Mahonri Sharp. "An Appreciation," *J. Alden Weir 1852-1919: Centennial Exhibition.* Exh. cat., American Academy of Arts and Letters, New York, 1952.

Zimmerman, Agnes. "An Essay Towards a Catalogue Raisonné of the Etchings, Dry-Points, and Lithographs of Julian Alden Weir," Metropolitan Museum of Art *Papers*: Vol. I, Pt. 2 (1923), pp. 1-50.

Credits

Designed by Carôn Caswell Lazar
Typeset in Garamond and Garamond Italic
Color Separations by The Studley Press, Inc.
Composed and Printed by The Studley Press, Inc., Dalton, Massachusetts
Printed on 80# Simpson Evergreen Recycled Text and Cover and 70# Curtis Retreeve
Recycled Text using Soybean based inks